FRITZ KAESER

A LIFE IN PHOTOGRAPHY

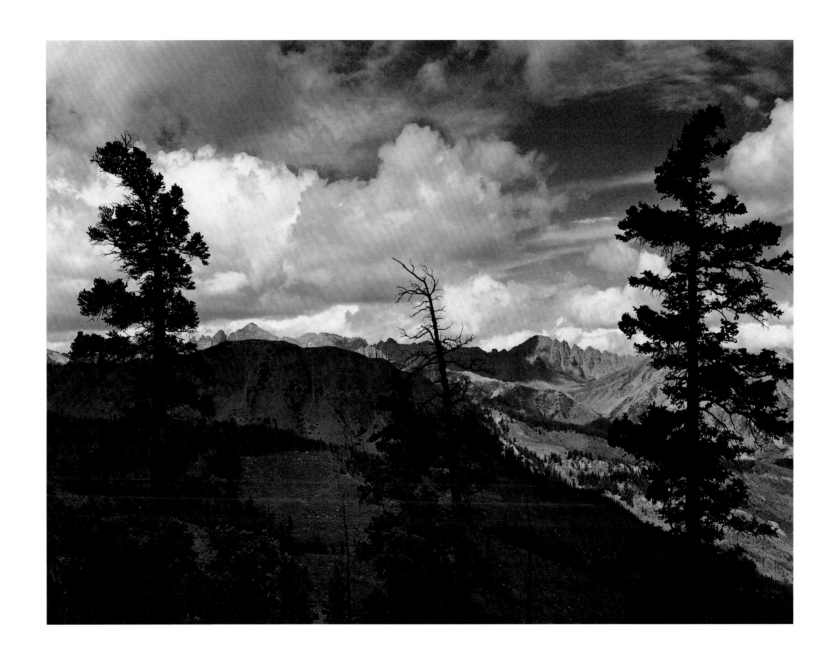

Castle and Cathedral Peaks, Colorado, 1954

FRITZ KAESER
A LIFE IN PHOTOGRAPHY

BY

STEPHEN ROGER MORIARTY

FOREWORD BY

DEAN A. PORTER

Published in conjunction with an exhibition of photographs
The Snite Museum of Art, University of Notre Dame
January 17 – March 14, 1999

UNIVERSITY OF NOTRE DAME PRESS
NOTRE DAME, INDIANA

We gratefully acknowledge the following
for permission to reproduce photographs:

Bob Bishop, for *Aspen Photographer's Conference, 1951.*
Copyright © by Robert C. Bishop, courtesy of
the Center for Creative Photography, Tucson.

The *Arizona Daily Star,* for José Luis Villegas,
Fritz Kaeser, 1985. Copyright © *Arizona Daily Star*.

The Snite Museum of Art, for all other photographs.
Copyright © Snite Museum of Art, University of Notre Dame.

Library of Congress Cataloging-in-Publication Data

Moriarty, Steve.
 Fritz Kaeser : a life in photography / by Stephen Roger Moriarty.
 p. cm.
 "Published in conjunction with an exhibition of photographs
 at the Snite Museum of Art, University of Notre Dame,
 January 17–March 14, 1999."
 Includes bibliographical references.
 ISBN 0-268-02852-4 (alk. paper)
 1. Photography, Artistic—Exhibitions. 2. Kaeser, Fritz,
 1910–1990—Exhibitions. I. Kaeser, Fritz, 1910–1990.
 II. Snite Museum of Art. III. Title.
 TR647.K23 1999
 779′.092—dc21 98-24610
 CIP

CONTENTS

FOREWORD

THE FIRST TIME I MET FRITZ KAESER, I mispronounced his last name, inserting a long "i" sound. He immediately corrected me, gently but firmly: "I am a KAYser, not a king!" I can honestly say that for the rest of our twelve-year friendship, I never heard another stern word from that decent and gentle man.

I always loved to sit and talk with Fritz and his energetic wife, Milly. While Fritz would ponder carefully before answering a question, Milly would jump right in with her opinion. This dynamic woman had learned a supreme self-confidence through her careers as a dancer, actress, teacher, and sculptress.

The only time I ever saw Milly's optimism falter was during a visit one afternoon in 1993 at her home in Tucson. Milly was deeply concerned over the future of the archive of her late husband's prints and negatives, which were still stored in his home darkroom. She had been frustrated in her attempts to find an institution willing to give them the care they deserved, and she looked at me with hopeful expectation.

For a split second, I hesitated. After all, the Snite Museum at Notre Dame already owned a large collection of Fritz's photographs. At my urging, in 1978 Fritz had begun to reprint a master set of his images, extending from the present back to his earliest days as a photographer. For several years thereafter, he regularly shipped meticulously labeled packages of hundreds of archivally processed photographs to the museum, and we had exhibited forty of them in 1983. When I replied that we would be delighted to accept the entire archive, Milly rolled her eyes to the heavens in a silent prayer of thanks. The next day, we packed and shipped thirteen boxes of material to Notre Dame.

For three years, a series of Notre Dame student interns sorted, catalogued, and stored almost two thousand prints and hundreds of negatives. It became a wonderful opportunity for them to learn museum standards and practices, as well as to obtain a hands-on familiarity with the complete body of work of an artist.

It soon was apparent that we now had a wealth of material that deserved to be exhibited and published. We were fortunate to have both the photographs from the Kaeser archives as well as the master set of reprinted photographs from which to select, since we discovered vintage exhibition prints of many of Fritz's most important images. The photographs presented here were chosen for their quality and as examples of all the stages of Fritz's artistic career. We hope that he would be pleased with our selection.

Fritz and Milly Kaeser have had a lifelong devotion to religion and the arts. They have supported the Snite Museum with endowments for purchasing liturgical art and for maintaining the gallery devoted to the Croatian sculptor Ivan Meštrović. Fritz gave of his time and wisdom by serving on our museum's advisory council, and Milly continues to be a staunch supporter of her beloved Desert House of Prayer in Tucson. In addition, for decades they encouraged and supported numerous other museums, artists, and religious charities all over the country.

Fritz may not have been a king, but he was an accomplished artist, a loving husband, and a generous man. It gives me great pleasure to be able to present this publication and exhibition of Fritz's photographs, not just for the education and enjoyment of the viewer, but as a way of saying "Thank you."

DEAN A. PORTER, PH.D.
Director
Snite Museum of Art
University of Notre Dame

ACKNOWLEDGMENTS

THE IDEA FOR AN EXHIBITION and catalogue of Fritz Kaeser's photographs originated with the Snite Museum's director, Dr. Dean A. Porter, who never wavered in his commitment to the project.

The actual processing of the Kaeser archives was carried out efficiently and professionally by a series of student interns. Morna O'Neill, Leanne Robinson, Emma Arnold, and Maria Culcasi did the initial sorting and cataloguing of almost two thousand photographs. Brandon Nappi and Rita Scheidler resleeved and inventoried the negatives. Zoë Van Cott graciously tolerated interruptions of her other tasks to "work on Fritz," while Meghan Dooher made slide sets of the final selection of prints. Special thanks should go to Sarah Jacobs, who has worked for three years on all stages of the project. Her patience and good humor have been appreciated almost as much as her skills on the computer.

Lee Marks, a friend and consultant, made invaluable suggestions regarding the text and the choice of the photographs. Frederick Sommer kindly agreed to be interviewed at his home in Prescott, Arizona, and the staff of the Center for Creative Photography in Tucson located and duplicated Kaeser's personal papers in their archives. Jim Langford, Jeannette Morgenroth, and Rebecca DeBoer at the Notre Dame Press efficiently expedited the publishing process to meet our deadline.

I thank my wife, Kathleen, who offered her professional expertise as a teacher of writing as well as her personal encouragement. Finally, I thank Milly Kaeser, who not only sat patiently for hours of oral interviews and cheerfully answered scores of questions over the telephone, but who also taught me an invaluable lesson: You can be young at any age.

STEPHEN ROGER MORIARTY
Curator of Photography
Snite Museum of Art

INTRODUCTION

FRITZ KAESER II photographed actively for over fifty years. During that time he enjoyed success as a pictorial salon photographer, ran several commercial studios, and was the official photographer for a unit of World War II ski troopers in northern Italy. After the war he focused on capturing the vast landscapes of the great western American mountains and deserts, and his romantic pictorial style gave way to the more contemporary mode of sharply focused, full-toned photographs. He began to look more closely at nature, and produced enlarged studies of minute, subtle textures and forms of rocks, plants, and discarded refuse.

Finally, after selling his last commercial studio, he launched into a whole new genre of experimental work. He manipulated and arranged his subject matter, he drew on the surface of his negatives with developer, and he solarized his prints, often producing images of total abstraction. It was as if the photograph had become interesting to him only as a record of the process behind it. Kaeser frequently quoted the painter and teacher Josef Albers: "Art is not an object, it is an experience."[1]

As a young man growing up in Illinois, Kaeser always dreamed of becoming an artist. After attending several universities, he enrolled in 1931 at the Art Institute of Chicago. He found himself using his camera more and more, and joined the Camera Club of Chicago. Several of his pictures were chosen to be in exhibitions. Encouraged by recognition of his work, he abandoned other artistic media and immersed himself totally in photography. After only a year in Chicago he moved to Laguna Beach, California, and became the first full-time assistant to the well-known pictorialist photographer William Mortensen.

Pictorialism was a movement with roots in nineteenth-century romanticism that reached its peak under the New York photographer and publisher Alfred Stieglitz. Stieglitz's movement, which he called the Photo-Secession, held that photographs, to be accepted as equal to the other visual arts, should not look like the products of a machine but rather should appear to be handcrafted.

Kaeser adopted a pictorial tool of Mortensen's and printed many of his early photographs through the "Mortensen screen," a plastic sheet that was covered with thousands of tiny crosshatch marks. The resulting photographs had a texture that was meant to suggest an etching or a drawing, as in Kaeser's self-portrait of 1934 (Plate 1).

Pictorial subject matter included the traditional categories of portraits, landscapes, nudes, and genre scenes. But in pictorialism, landscapes were usually moody and evocative, nudes were depersonalized, and portraits were often of "types," such as artists (Plate 10), peasants (Plate 2), or characters from classical art and literature (Plate 7). For the first ten years of his career, most of Kaeser's personal photography was in this style.[2]

After one year in California, Kaeser rejoined his parents in Madison, Wisconsin, and opened a studio and camera store in 1933 (Figures 1 and 2). He performed the many tasks of a small-town commercial photographer, while at the same time submitting work to numerous salon and publication contests. That year he met and married Milly Tangen, a dancer studying at the University of Wisconsin (Figure 3).

Besides the love and friendship of a long and successful marriage, Milly brought another gift to Fritz Kaeser: the world of the performing arts, especially music and dance. Kaeser became known as a photographer of dancers, and his portraits of José Limón and Harald Kreutzberg were widely exhibited and reproduced in magazines (Plates 3 and 4).

Kaeser continued photographing dancers and performers at summer arts festivals after he bought land near Aspen,

Figure 1 *Exterior of Fritz Kaeser's Madison Studio and Store, 1938*

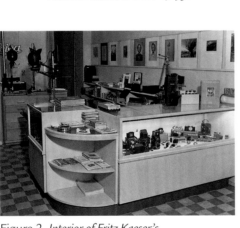

Figure 2 *Interior of Fritz Kaeser's Madison Studio and Store, 1938*

Figure 3 *Milly Kaeser Dance, "The Cat," Wisconsin Union Theater, 1941*

Figure 4 *Commercial Illustration of Toweling, circa 1937*

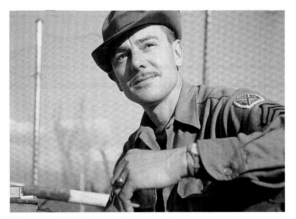

Figure 5 *Self-Portrait, Florence, Italy, 1945*

Colorado, but then began to concentrate on the landscape. Except for his commercial work, the natural world would be his favorite subject for the next twenty years, first in the Rocky Mountains and later in the Sonoran Desert.

In 1945, after he returned from a stint with the ski troopers in northern Italy, Kaeser took a six-week class in photography in San Francisco with Ansel Adams. In 1945 and 1946, he also finally abandoned the pictorial style, and only created images that were sharply focused in all areas and printed on smooth commercial paper without toners. This style of work, which became known as "straight photography," was a manifestation of the modernist movement that had became dominant among many fine art photographers after World War I.

It is tempting to attribute Kaeser's change in style from pictorialism to straight photography to the influence of Adams, but this would be too simple. Kaeser was no newcomer to straight photography. Early in his career he had produced clear, sharp, direct prints when it was required for commercial work (Figure 4). Nor was Kaeser a stranger to the "pictorial vs. straight photography" debate, since his library already contained well-thumbed photographic books by Edward Weston, Paul Strand, Brassaï, and Beaumont Newhall.

Some of Kaeser's 1945 Italian photographs (Plates 12, 13, 14) and the Latin American pictures from 1946 to 1947 (Plates 15, 16, 18) are reminiscent of pictorialism, but the final prints show none of the soft focus, physical manipulation, or special toning that he had used in the 1930s. Fritz Kaeser was a thoughtful, secure man who was not afraid of change. He had begun to observe the world with a new clarity and directness, and his photographs were the external visual evidence of his new way of seeing.

By the early 1950s Kaeser had reached his stride as a photographer, and he worked with great mental and physical energy. From his studio at Aspen (Figure 6) he regularly sallied out onto the slopes and shot numerous early views of skiing, which was just starting to catch on in America as a

winter sport (Plate 23). The famous skier André Roch was one of his favorite subjects, and tourists and editors alike eagerly purchased the resulting images (Plate 19). Kaeser hiked extensively in the high Rockies, carrying his heavy tripod and camera in a backpack. There he found a subject that he photographed repeatedly for a number of years: the Maroon Bells.

The Maroon Bells are a series of enormous rock projections that rise dramatically above Maroon Lake outside of Aspen. Today they are one of the most photographed spots in America, and hordes of tourists are disgorged like clockwork out of shuttle buses that drop them by the edge of the lake, where they snap a few frames and depart. In Kaeser's day the spot was much more remote, and in winter the only access was on cross-country skis (Figure 7). The large number of negatives in his archives indicate that something about the place was special to him, and he photographed the mountains throughout the seasons, experimenting with different angles, distances, and times of day.

In one view, the peaks are buried under snow, casting luminous reflections in the half-frozen lake (Plate 28). In another shot, the lake has become almost transparent, and the rocks on the bottom merge with the reflected forms of white clouds, in a kind of optical illusion (Plate 30). The peaks sometimes disappear behind storm clouds (Plate 26) or diminish in size and importance as Kaeser moved his camera farther up the valley (Plate 29).

In one photograph the right half of the picture is filled with a jumbled pile of branches, which assume a size and significance equal to the majestic Bells beyond (Plate 25). This image shows that Kaeser was already becoming fascinated with tumbling, seemingly chaotic forms in nature, a motif that became increasingly common in his later work (Plates 58, 59, 62).

In 1951 an event occurred in Aspen that energized both Kaeser and the entire American photographic community. That summer the philanthropist Walter Paepcke of the Aspen Institute for Humanistic Studies sponsored a national

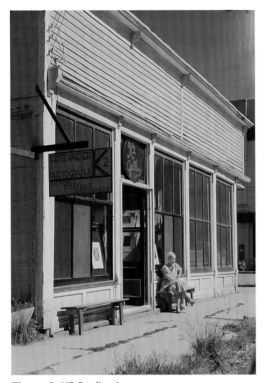

Figure 6 *K2 Studio, Aspen, 1952*

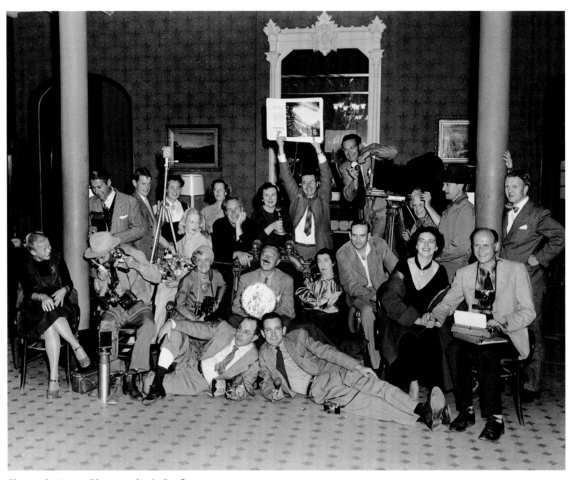

Figure 8 *Aspen Photographer's Conference, 1951*

(LEFT TO RIGHT)

LYING ON FLOOR Will Connell, Wayne Miller

SEATED IN SECOND ROW Milly Kaeser, Ansel Adams, Dorothea Lange, Walter Paepcke, Berenice Abbott, Frederick Sommer, Nancy Newhall, Beaumont Newhall

BACK ROWS Herbert Bayer, Eliot Porter, Joella Bayer, Aline Porter, Mrs. Paul Vanderbilt, Minor White, Mrs. Steele (secretary to Paepcke), John Morris, Ferenc Berko, Laura Gilpin, Fritz Kaeser, Paul Vanderbilt

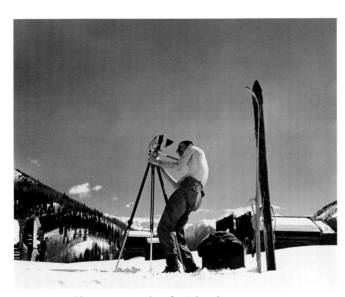

Figure 7 *Self-Portrait at Ashcroft, Colorado, 1941*

conference on the future of American photography. Among those attending were Ansel Adams, Minor White, Dorothea Lange, Berenice Abbott, Eliot Porter, Laura Gilpin, Frederick Sommer, Herbert Bayer, Wayne Miller, and Beaumont and Nancy Newhall. They "talked shop" from early morning to late at night, argued photographic theory, viewed prints and slide shows of each other's work, and slipped out into the early morning light with their cameras. Years later, participants fondly recalled the nonstop discussions and heated arguments that went on almost continuously for ten days.[3] As the local studio photographer, Kaeser was invited to give a keynote address, and he also organized photographic excursions to scenic points around the Aspen area.

A photograph of all the participants gathered in the lobby of the Hotel Jerome shows them in high spirits, laughing and joking (Figure 8). Milly Kaeser sits on the far left, where Ansel Adams, comically draped in all kinds of photographic equipment, studies her legs through a light meter. Kaeser looks on from across the room, smiling benignly.

The conference was a heady experience for Kaeser, who suddenly found himself accepted as an equal by the avantgarde of American photography. He later recalled that the Aspen conference was a time of "intense, concentrated, serious and free discussion of photography. [It] was one of the most interesting and valuable experiences of my long career as a photographer."[4]

One photographer who attended, Frederick Sommer, seems to have had a very strong influence on the direction of Kaeser's work. Sommer (who is now in his nineties and still photographing) became an occasional house guest of the Kaesers after the conference. Milly Kaeser remembers Fritz and Sommer sitting outside on their deck for hours at a time, deep in discussion.

Sommer is noncommittal about his possible influence on Kaeser, suggesting that such things are probably inevitable and possibly unimportant.[5] Nevertheless, in the 1950s Kaeser began to share Sommer's visual interest in certain telling details of the natural world, such as textures of rocks and plants that had been blasted by the elements,

and objects found abandoned in the desert (Plates 57, 68, 69).

For Kaeser, these images became a way of exploring the very meaning of life itself. When asked about his desert close-ups, Kaeser would often quote from William Blake's "Auguries of Innocence":

> To see a World in a Grain of Sand
> And a Heaven in a Wild Flower,
> Hold Infinity in the palm of your hand
> And Eternity in an hour.

He was more specific in notes he jotted down for a radio interview in Tucson:

> Photography becomes a medium of expression (not self-expression) when used to explore and discover new and previously unseen images and forms in nature, and as a functional art form [it] reveals pattern, design, and ordered arrangement in nature.
> [Photography] may point the way to understanding nature's larger design, ecological integration. In the desert [are] life, death, disintegration, rebirth; these are ever apparent and visually overwhelming. Desert life cycles may be complete in hours, birth to rebirth, or perhaps centuries, for either plant or animal.[6]

A number of Kaeser's nature studies resemble photographs by the Trappist monk Thomas Merton. It is unlikely that Kaeser had seen any of Merton's photographs before beginning his own nature studies, since they were not published until 1970, two years after Merton's death. However, Kaeser was familiar with Merton's writings, and it is useful to compare Kaeser's words with an excerpt from Merton's essay, "Hagia Sophia":

> There is in all visible things an invisible fecundity, a dimmed light, a meek namelessness, a hidden wholeness. This mysterious Unity and Integrity is Wisdom, the Mother of all, Natura naturans.
> There is in all things an inexhaustible sweetness and purity, a silence that is a fountain of action and of joy. It rises up in wordless gentleness and flows out to me from the unseen roots of all created being. . . .[7]

Kaeser, like Merton, came to see photographs as metaphors for reality rather than actual depictions or

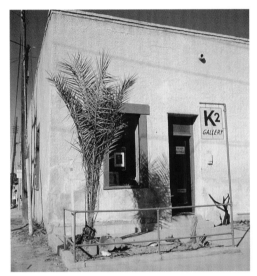

Figure 9 *K2 Studio, Tucson, 1954*

Figure 10 *Self-Portrait, 1955*

Figure 11 *Dorothy Day, 1958*

transcriptions of the natural world. Knowing this, it is easier to understand why Kaeser began to create a completely new body of work after his retirement in 1963. The new prints were the result of photographing surreal tableaux constructed from bones, shells, rocks, linoleum, and pieces of wire, and of intense periods of darkroom experimentation, utilizing solarization, negative printing, and painting directly with developer onto negatives before printing them (Plates 72, 78).

Unlike his earlier portraits and landscapes, this material is difficult for many viewers to approach. Kaeser knew that, and once explained, "To me, photography has made a full circle. It began imitative of painting, then became pure, sharp, objective. Now I see it returning to pictorialism, as more subjective. . . . Photographs that don't look like photographs."[8]

It is true that the new images did result from physically altering the print or the negative or both, but they did not resemble the pictorial prints of the 1930s. Many of them have no recognizable subject matter. Their forms were playfully created in Kaeser's mind, and not by the traditional action of light reflecting off a physical object and into a camera (Plate 77). One exception is the group of studies of bones or shells (Plates 74, 76, 79).

It is possible that many of the late images grew out of Kaeser's continuing meditation on his own mortality, on "nature's larger design." Skulls are a frequent referent to death in Western art, such as those that appear in the paintings of Georgia O'Keeffe, whom Kaeser had photographed at Ghost Ranch in 1968. Kaeser's version, "Artifacts: Buffalo" (Plate 73), depicts two skulls floating on a field of black. The one on the right seems to be coming closer, inevitably advancing towards the viewer. Death approaches, but in a form that invites contemplation rather than fear.

The Desert House of Prayer is a small retreat center, a cluster of low buildings on the edge of Tucson, Arizona, where the suburbs push up against the desert hills. In the main building is a library for the use of the retreatants, and on a small wooden table rests a somewhat tattered portfolio of Kaeser's photographs.

Inside the portfolio is an array of images that span much of Kaeser's career. The seashells and buffalo skulls are there, as well as approaching storms and snowbanks in the Rockies, Guatemalan pilgrims, a Greek monastery, cacti, clouds, and worm trails in old boards. A handsome portrait of Georgia O'Keeffe rests next to close-ups of linoleum scraps and rusted stoves. The images of abstract chemical smears coexist with a picture of the moon rising over a Spanish colonial church. The portfolio sits quietly, awaiting the possibility that one of the retreatants may pick it up and peruse the photographs inside.

It was Fritz Kaeser's generous hope that his photographs could help others to understand what he had come to believe, that beneath the exterior of the world is not the formlessness that leads to despair, but rather "a hidden wholeness."

NOTES

1. Joseph Albers, "Art as Experience," *Progressive Education,* October 1935.

2. For an excellent study of the milieu of later American pictorialist photographers like Kaeser, see Christian A. Peterson's *After the Photo-Secession: American Pictorial Photography, 1910 – 1955* (New York: W. W. Norton and Co., 1997).

3. Beaumont Newhall, "The Aspen Photo Conference," *Aperture* 3, no. 3 (1955): 3-10.

4. From a handwritten page in the Kaeser file in the archives at the Center for Creative Photography, Tucson, Arizona.

5. From an interview with Frederick Sommer at his home in Prescott, Arizona, June 16, 1995.

6. From the Kaeser file in the archives at the Center for Creative Photography, Tucson, Arizona.

7. Thomas Merton, *Emblems of a Season of Fury* (New Directions, 1963). Merton's photographs were collected after his death by John Howard Griffin, and published as *A Hidden Wholeness: The Visual World of Thomas Merton* (Boston: Houghton Mifflin, 1970).

8. From an interview published in the *Arizona Daily Star,* Tucson, Saturday, July 27, 1985.

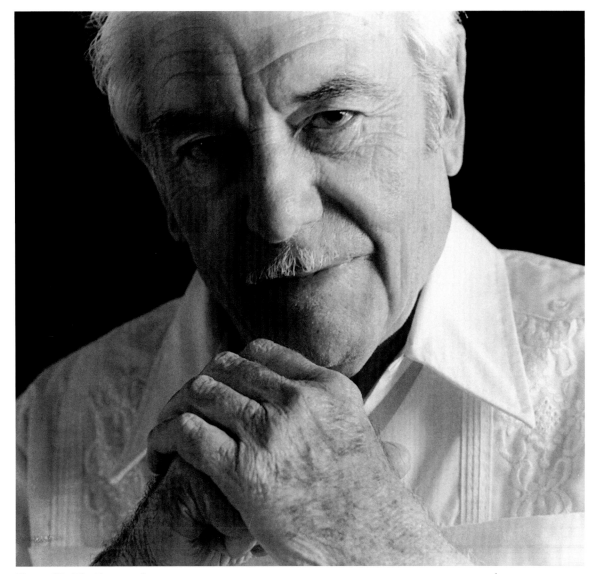

Figure 12 *Fritz Kaeser, 1985* JOSÉ LUIS VILLEGAS

CHRONOLOGY

1910

Frederick "Fritz" Kaeser II was born on July 3 in Greenville, Illinois, near St. Louis, Missouri. His grandfather, Frederick "Fritz" Kaeser, emigrated from Glarus, Switzerland, and was the inventor of evaporated milk and cofounder of the Pet Milk Company. Kaeser's father, William, was a lawyer and the midwest manager of Pet Milk; his mother was Clara Vögt. His older brother, William, became an architect, and his younger brother, George, an engineer. Both are deceased.

1920

At age ten, Kaeser assembled his first photo album from Brownie camera snapshots. His first subject was his dog, who refused to stand on a stump and look into the camera. He traded his Brownie for a Graflex and continued photographing in high school.

1928

Kaeser enrolled in the program of industrial arts education at the University of Illinois.

1928–1931

Kaeser studied applied art at the University of Wisconsin in Madison, where his family had moved while he was a junior in high school. His father encouraged him to go to the Art Institute in Chicago if he "really wanted to be an artist."

1931–1932

Kaeser moved to Chicago to study at the Art Institute. He joined the Chicago Camera Club and won a bronze medal from a photographic competition in Switzerland.

1932–1933

Kaeser went to Laguna Beach, California, to become the first full-time assistant to pictorial photographer William Mortensen. He worked in Mortensen's darkroom and on location shoots. He photographed around Hollywood and Los Angeles, and shot publicity photos of actors and actresses, including Bette Davis.

1933

Kaeser returned to Madison, Wisconsin, and set up a camera store and studio with the help of his father. His studio was first located on the third floor of a bank building and later on State Street.

Fritz Kaeser met Mildred "Milly" Tangen on a blind date. Milly had been born in 1911 in Two Rivers, Wisconsin, where early success in amateur dance contests inspired her studies at the University of Wisconsin. She majored in dance education and was a member of Orchesis, an honorary dance society. They married in December.

1934

The couple honeymooned at Laguna Beach, visiting Mortensen and his favorite model, Meredith, who later became his wife. Kaeser's architect brother William designed a house for the couple in Madison, with a large open room where Milly could dance and give lessons. Frank Lloyd Wright was an occasional guest, along with assorted dancers and artists. (A description of the Kaesers' neighborhood in Madison at this time can be found in Wallace Stegner's novel *Crossing to Safety*.)

1938

Fritz and Milly Kaeser traveled to Steamboat Springs, Colorado, for the Perry Mansfield dance camp, which also had a theatrical school. Dancers Martha Graham, José Limón, Hanya Holm, and Doris Humphrey often appeared there, and Kaeser photographed their performances.

Kaeser then went to Aspen to ski and photograph the mountains. He fell in love with the area and bought six-and-a-half acres of land for two hundred dollars from the woman who had originally homesteaded the valley. He hired her sons to build a log cabin.

Around this time, the Swiss skier André Roch convinced the town to cut ski trails down the mountain. Kaeser became known as a ski photographer, and the Kaesers went back and forth between Madison and Aspen for several years. Frederika Cutcheon ran Kaeser's Madison studio in his absence. She needed more help when Kaeser entered the army in 1943, so she hired young John Szarkowski, who later became the curator of photography at the Museum of Modern Art.

1933–1944

Kaeser exhibited in numerous pictorial photographic salons, including ones held in Chicago, Milwaukee, Philadelphia, Boston, New York, Canada, and Switzerland. His photos were published in *American Photography, Camera Craft, U.S. Camera,* and its annual publication, *Pictures of the Year*.

1940

Milly went to New York to continue her dance studies. She studied with Martha Graham, Francisco Boas, Hanya Holm, and Lisa Parnova, and also danced in Holm's company.

1943–1945

In the spring of 1943, Kaeser received a draft notice. He had admired the ski troopers who were training around Aspen and decided to enlist with the 10th Mountain Division stationed at Camp Hale, Colorado. Milly moved into a hotel in Colorado Springs and joined the Martha Wilcox dance company.

Kaeser became a photographer for the division newspaper, *The Blizzard*. He later joked, "We shot pinup pictures of mountains." Sent to northern Italy late in the war, he photographed ski troopers in Austria and Yugoslavia and landscapes in northern Italy.

1945

After his discharge from the army, Kaeser sold his Madison studio and he and Milly moved temporarily to San Francisco. He studied photography for six weeks with Ansel Adams.

1946–1950

Kaeser and his wife traveled through Central and South America for almost a year, between 1946 and 1947. Kaeser's K2 studio in Aspen continued to operate as a full-time, year-round, general commercial studio for these four years. In addition to shooting portraits and routine commercial assignments, Kaeser also sold landscape photographs to tourists. He was often hired to photograph dancers, musicians, and performances at the many summer festivals and at the Aspen Institute for Humanistic Studies. He became known as a specialist in ski photography and took numerous photographs of the Maroon Bells, a strikingly scenic group of peaks near Aspen.

1948

Kaeser won the Graflex World-Wide Photo Contest for a picture of the skier André Roch. He studied lithography at the School of Fine Arts, Colorado Springs.

1950

The Kaesers built a home in the hills overlooking Tucson, Arizona. They established another K2 studio in one of the older adobe buildings of a run-down section of Tucson called Ash Alley, which is now an artists' area. The Kaesers began spending summers in Aspen and the rest of the year in Tucson, operating the K2 studio in Aspen only during the summer months.

1951

Kaeser lectured and sat on a panel at the first photographic conference of the Aspen Institute of Humanistic Studies. Participants included Ansel Adams, Minor White, Dorothea Lange, Berenice Abbott, Eliot Porter, Laura Gilpin, Frederick Sommer, Herbert Bayer, Wayne Miller, and Beaumont and Nancy Newhall.

1953

Kaeser had a one-person show at Oberlin College, Ohio, and was represented in the Detroit Institute of Fine Arts' International Photography Exhibition.

1954

Kaeser was given one-person shows at the University of Texas and at the Tucson Art Association, which later became the Tucson Museum of Art. He was elected president of the Tucson Art Association.

Kaeser began spending more time collecting and polishing minerals and gems. He had a lapidary workshop installed in two huge redwood water casks beside his house. He was one of the founders of the Tucson Gem and Mineral Society.

1955

Kaeser had a one-person show at the opening of the Palm Springs Desert Museum. Milly Kaeser was baptized into the Catholic Church. Frances O'Brien (longtime friend and companion of Georgia O'Keeffe) was her godmother.

1956

Kaeser had a one-person show at the University of Wisconsin.

1957

Fritz Kaeser was baptized a Catholic. The Kaesers became familiar with Dorothy Day, Thomas Merton, and other Catholic intellectuals. They became increasingly intrigued with liturgical art and the architecture of churches.

1958

The Kaesers celebrated their twenty-fifth wedding anniversary by driving around Europe for a year.

1960

Kaeser received the Jay Stenberg Memorial Award from the Tucson Fine Art Association.

1962

Kaeser closed his K2 studios in Aspen and Tucson, retired from commercial work, and began photographing solely for personal expression.

1963

Kaeser exhibited with Ansel Adams, Brett Weston, Eliot Porter, Wynn Bullock, and Van Deren Coke in the Invitational Photography Show of Photographers from the Southwest, at the Tucson Art Center.

1965–1972

The Kaesers established and operated the Kino Gallery in Tucson, a space where shows were given to artists producing liturgical and religious art in all media.

1965

Kaeser exhibited his own architectural photographs of European churches at the Kino Gallery, Tucson.

1968

The Kaesers were invited to Ghost Ranch, New Mexico, where Fritz Kaeser made a series of portraits of Georgia O'Keeffe.

1978

Kaeser was featured in a retrospective exhibition at the Applequist Gallery, Aspen, Colorado.

1979

Kaeser became a member of the advisory council of the Snite Museum of Art at the University of Notre Dame. He began printing a master set of his photographs, including examples from all periods of his personal work.

1980

Kaeser won a prize in the Ilford International Photography Competition for a print of André Roch skiing. The Kaesers endowed a gallery at Notre Dame to exhibit the work of the Croatian sculptor Ivan Meštrović, and established an endowment to purchase liturgical art.

1983

Kaeser was given a retrospective exhibition at Notre Dame's Snite Museum. Kaeser donated over three hundred master prints to the museum's collection. The Kaesers visited their cabin in Aspen for the last time, afterwards living solely in Tucson.

1984

Kaeser suffered a heart attack, and underwent a series of operations over the next several years.

1986

The Tucson Festival Society exhibited fifty of Kaeser's photographs. He donated one hundred prints to the Tucson Museum of Art, along with $3,000 gleaned from the sale of his photographs. The Denver Public Library showed Kaeser's photographs relating to the history of skiing in Aspen and the U.S. Army's 10th Mountain Division.

1989

Kaeser was honored with simultaneous exhibitions at the Center for Creative Photography and the gallery of the University of Arizona Department of Art. Kaeser donated his cameras, darkroom equipment, and personal papers to the Center for Creative Photography at the University of Arizona.

1990

Frederick "Fritz" Kaeser II died on June 6 in Tucson, Arizona.

1993

Kaeser photographs were included in "Churches of New Mexico and Arizona," Roswell Museum, New Mexico.

1994

Milly Kaeser donated Fritz Kaeser's negatives and prints to Notre Dame. A Kaeser photograph appeared in a show organized by the University of Indiana Art Museum, "Spiritual Foundations: Photography of America's Sacred Structures." Several photos were exhibited at the Valparaiso University Art Museum, "Recent Acquisitions."

1999

A retrospective exhibition of Fritz Kaeser's photographs, with an accompanying catalogue, was presented by the Snite Museum of Art, University of Notre Dame.

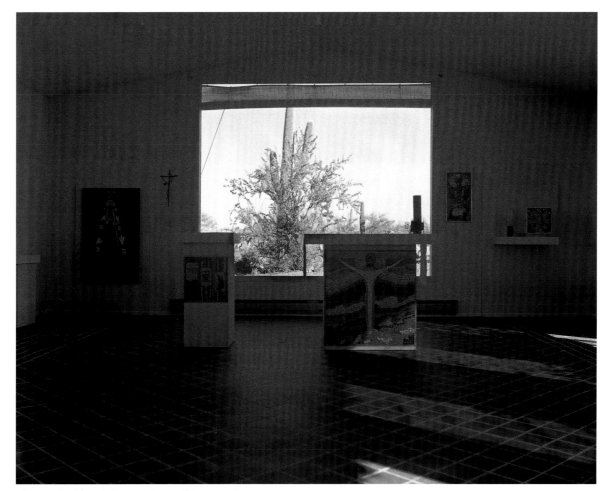

Figure 13 *Chapel, Desert House of Prayer, 1982*

PLATES

PICTORIAL

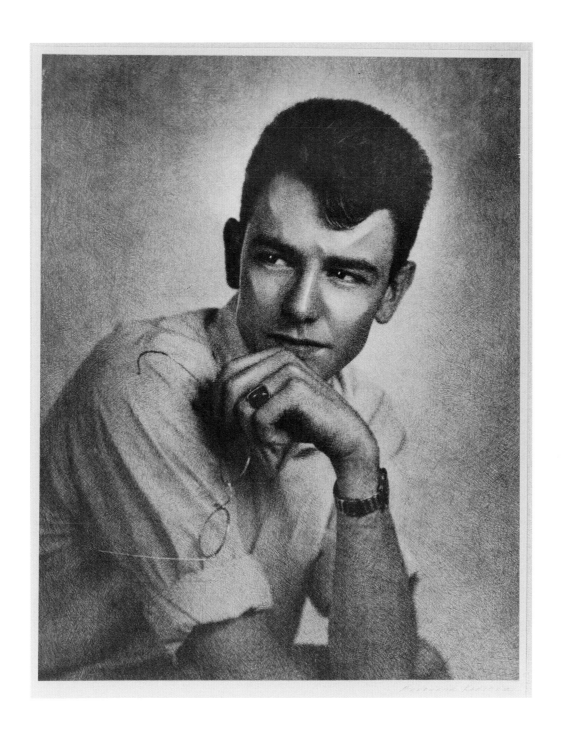

1 *Frederick Kaeser II, Self-Portrait, 1934*

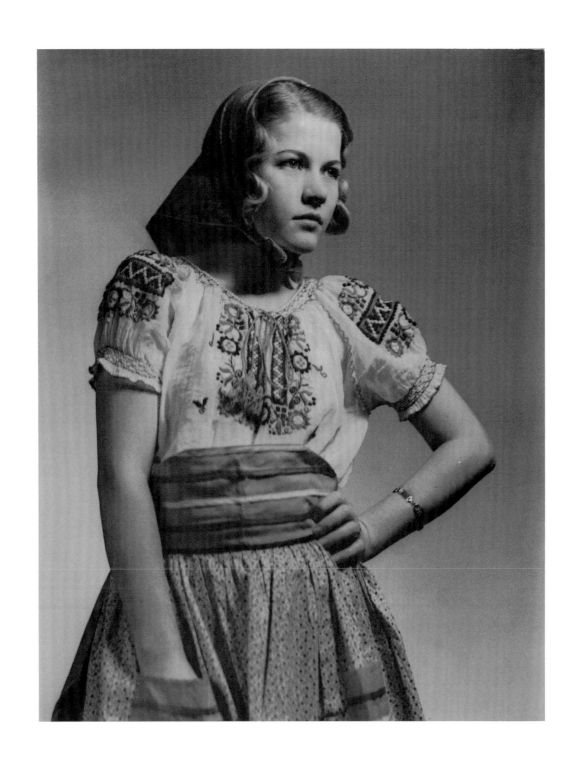

2 *Girl in a Folk Costume (Milly Kaeser), circa 1935*

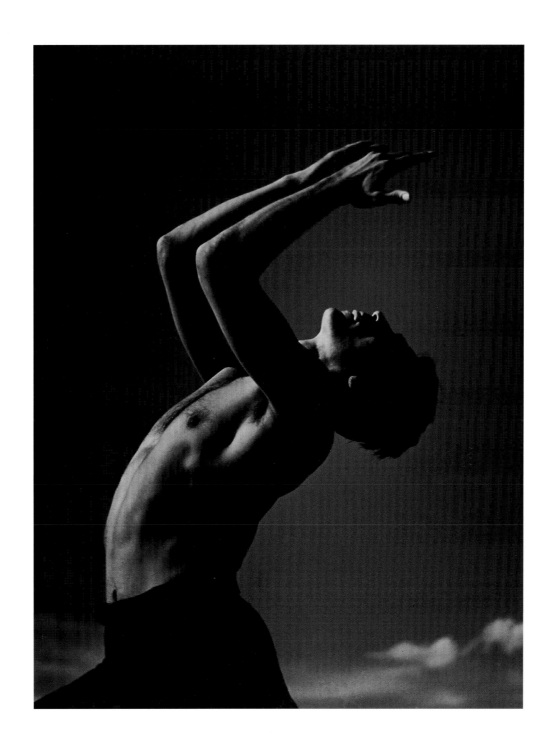

3 *José Limón, Dance of Mexico, 1941*

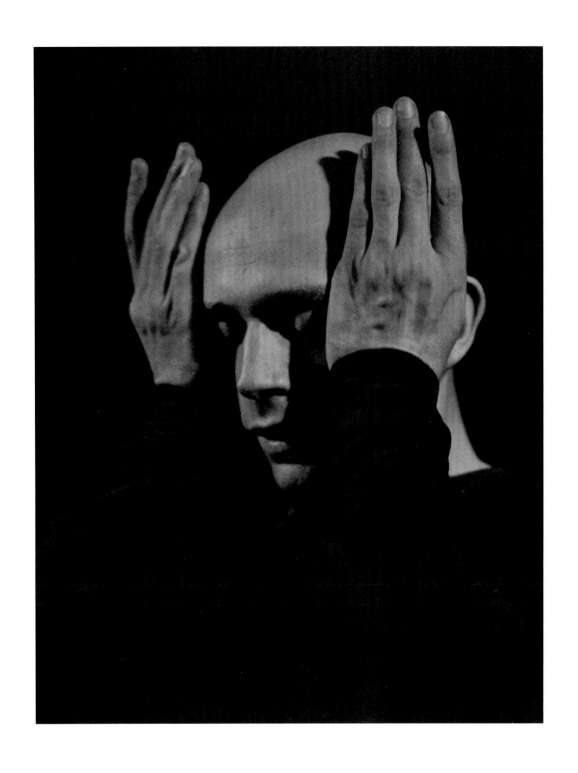

4 *Harald Kreutzberg, circa 1940*

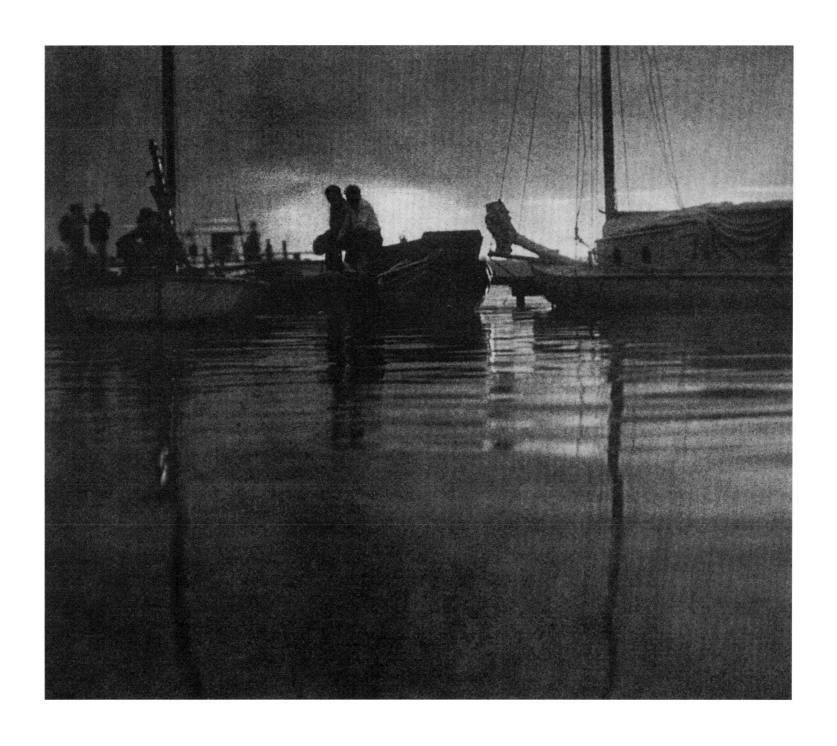

5 *The Dreamers, 1934*

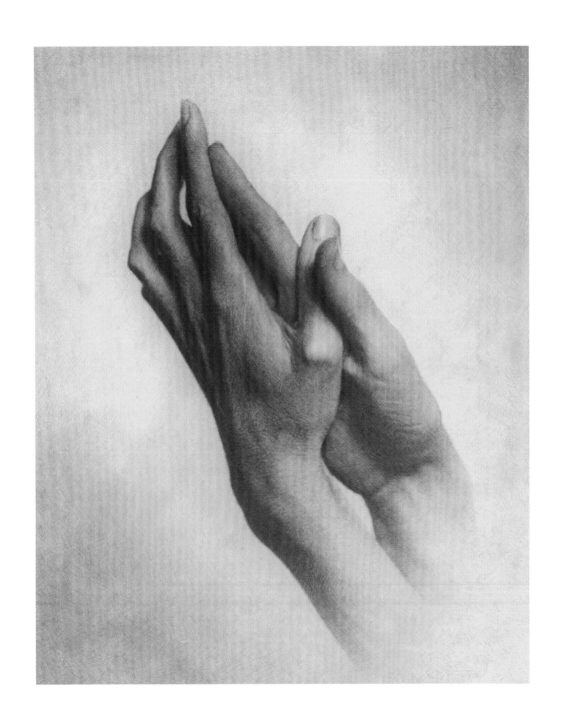

6 *Study of Hands, 1933*

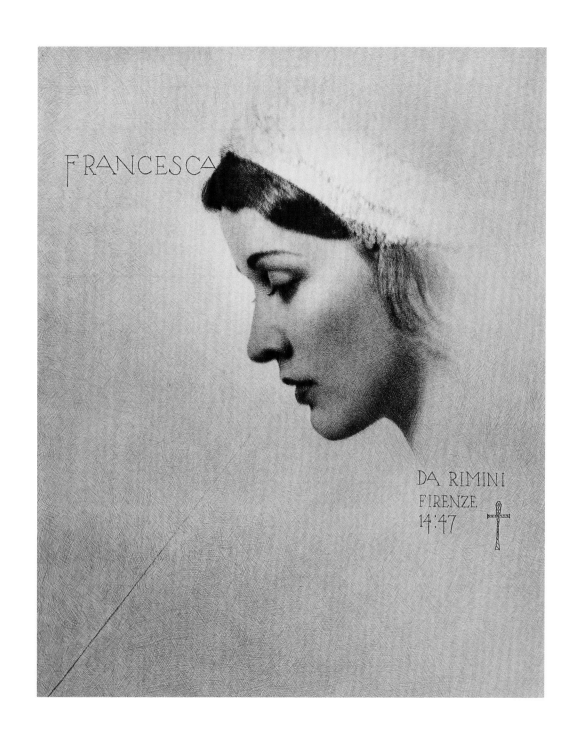

7 *Francesca, Student Actress, Madison, circa 1934*

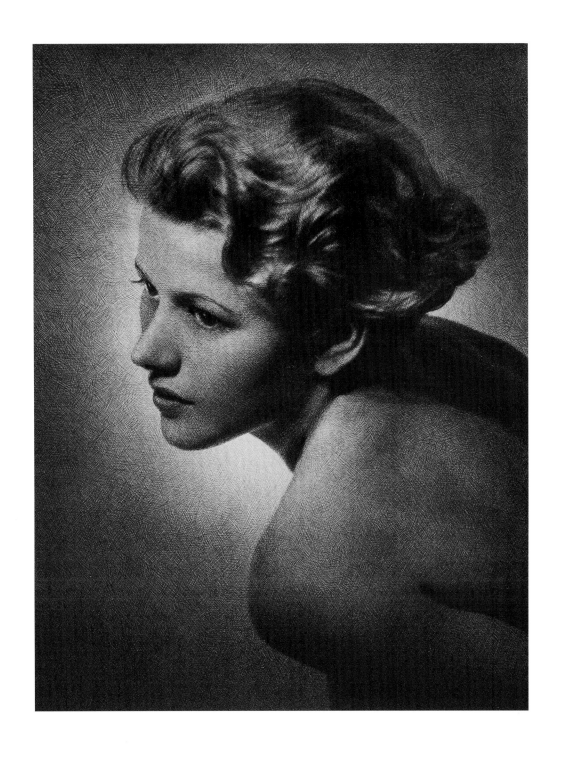

8 *Myrtoclea, 1935*

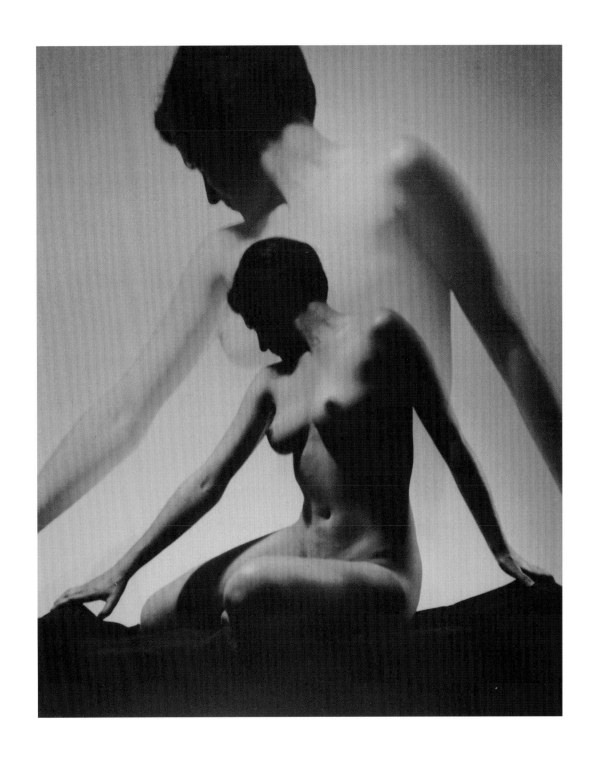

9 *Figure, 1939*

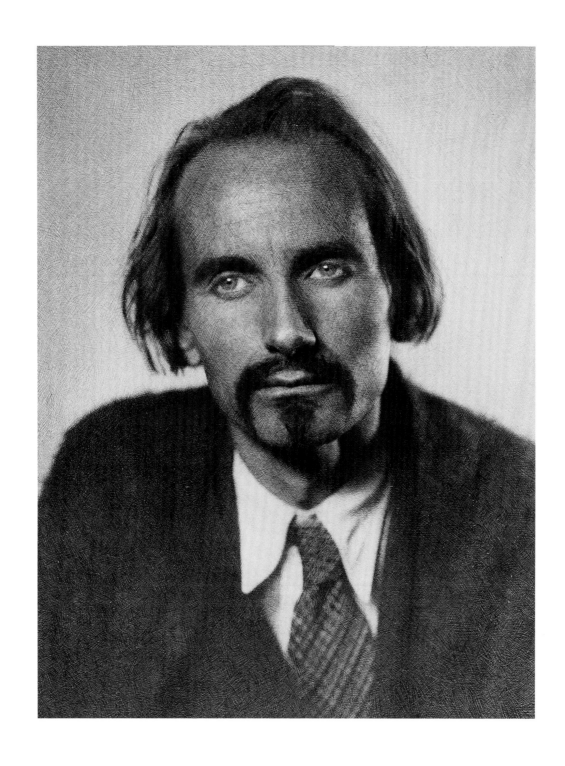

10 *Robert Louis Stevenson Portrayed by George Dunham, 1932*

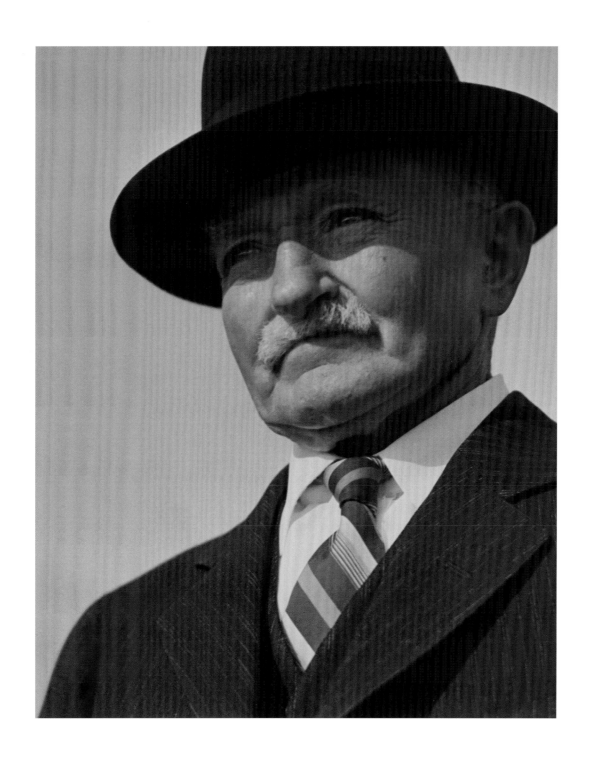

11 *My Swiss Uncle Jake, circa 1940*

TRAVEL

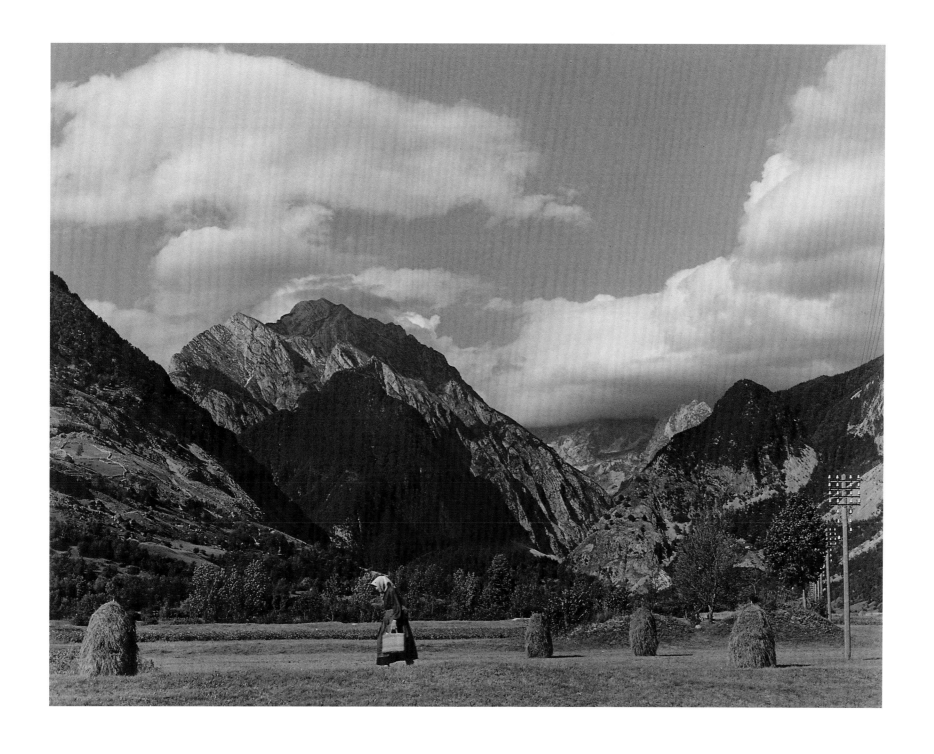

12 *Isonzo Valley, Italy, 1945*

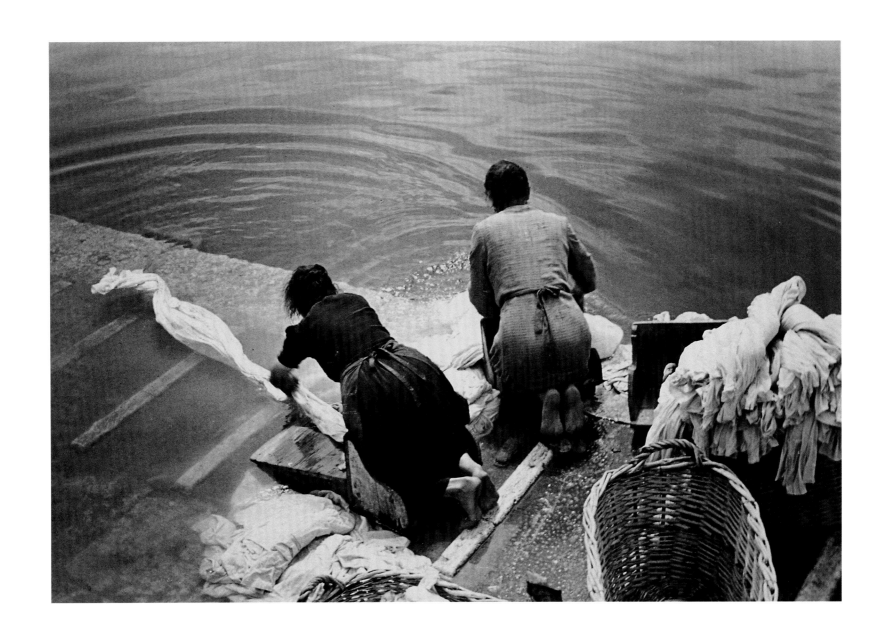

13 *Washing in Lago di Garda, Italy, 1945*

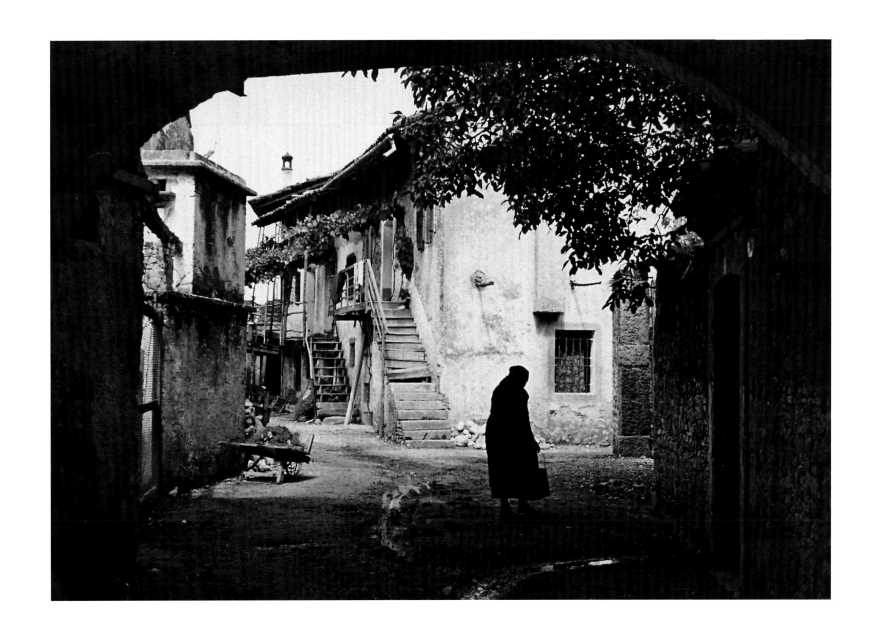

14 *Zirocco, Venezia, Italy, 1945*

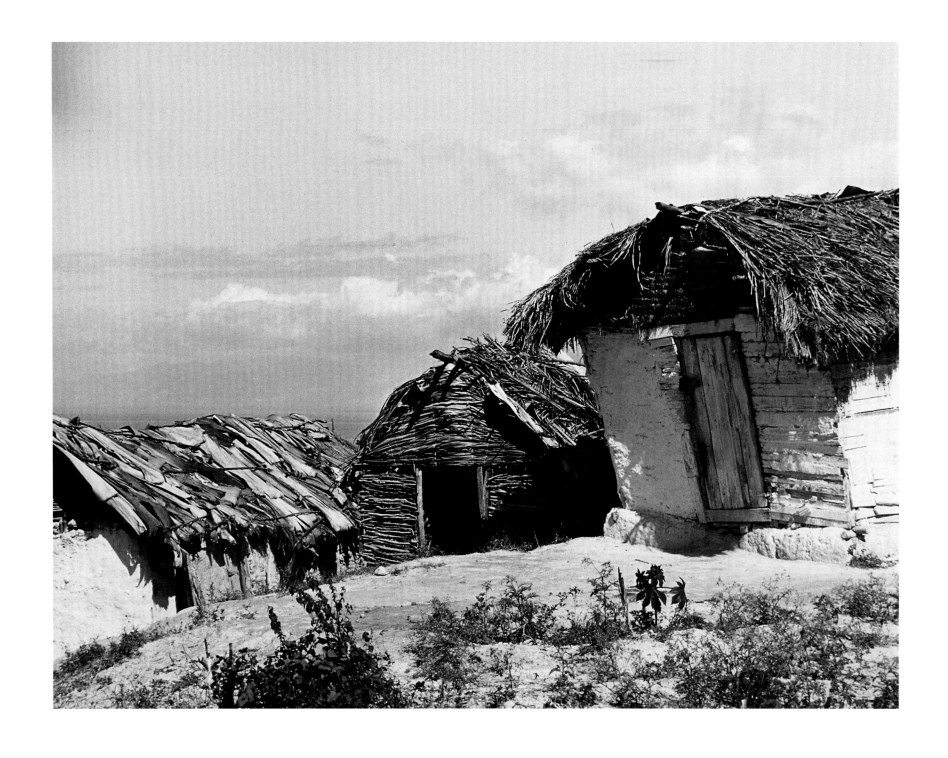

15 *Haitian Huts, 1946*

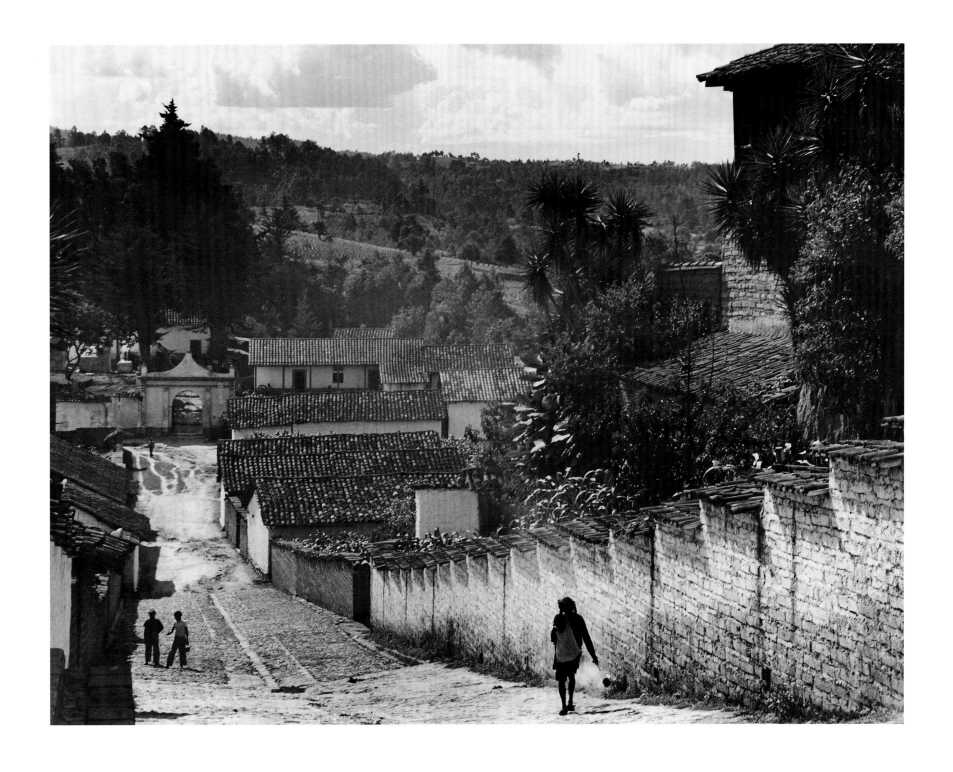

16 *Chichicastenango, Guatemala, 1946*

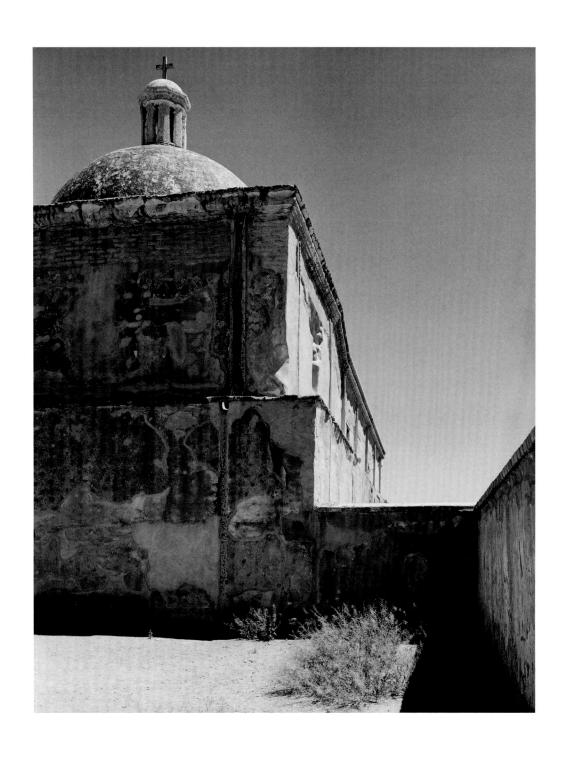

17 *Abandoned Mexican Church, 1946*

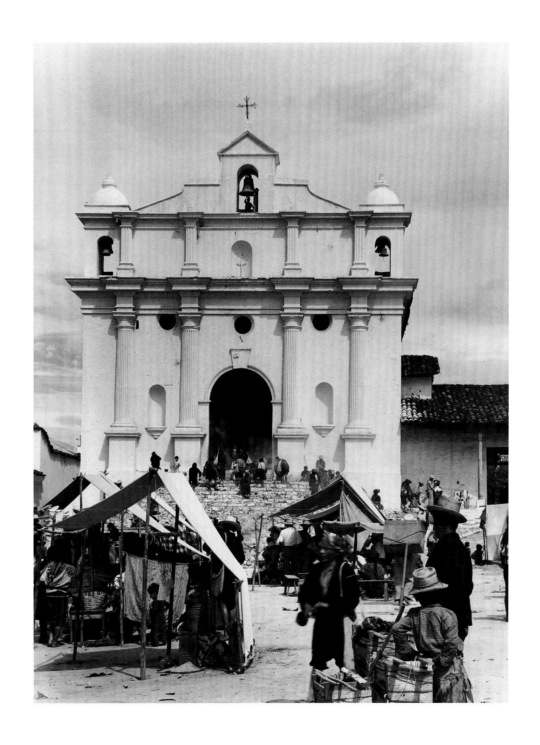

18 *Guatemala: Chichicastenango Market & Church, 1946*

SNOW & SKIING

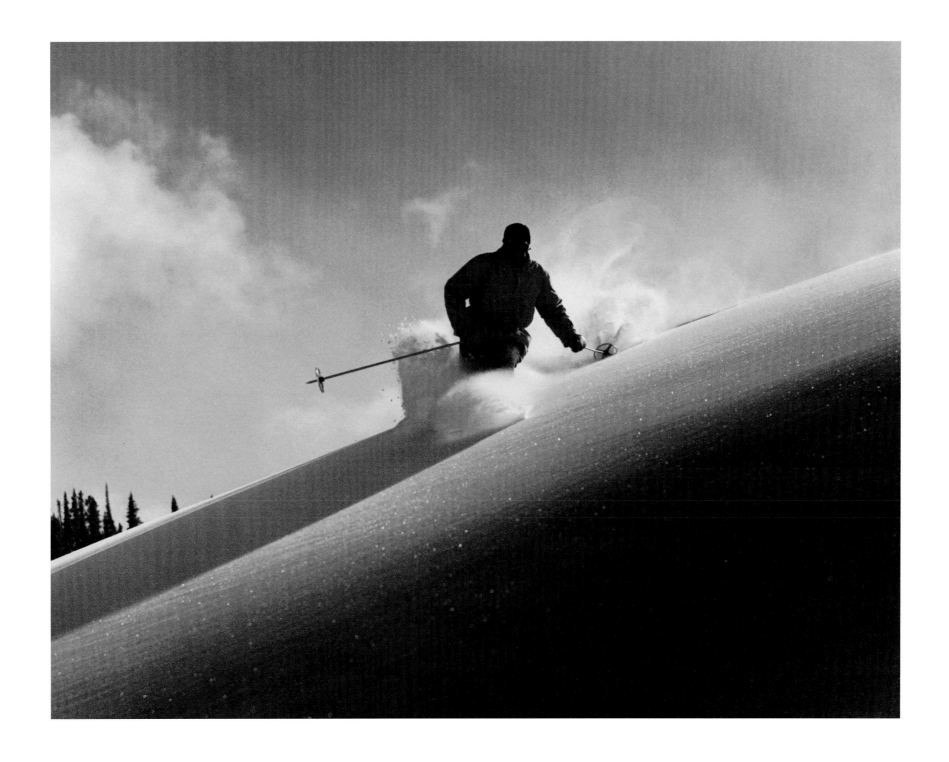

19 *André Roch Skiing, 1949*

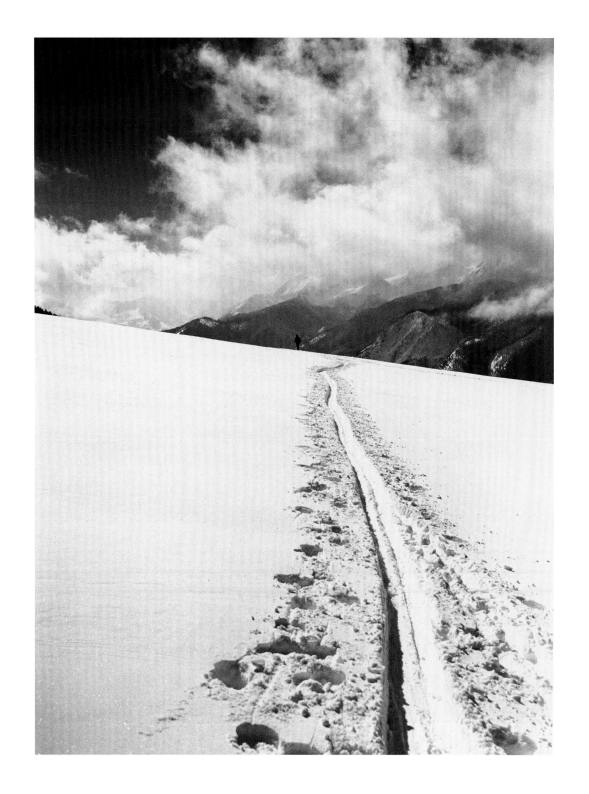

20 *Ski Trail on Richmond Hill (Aspen, Colorado), 1941*

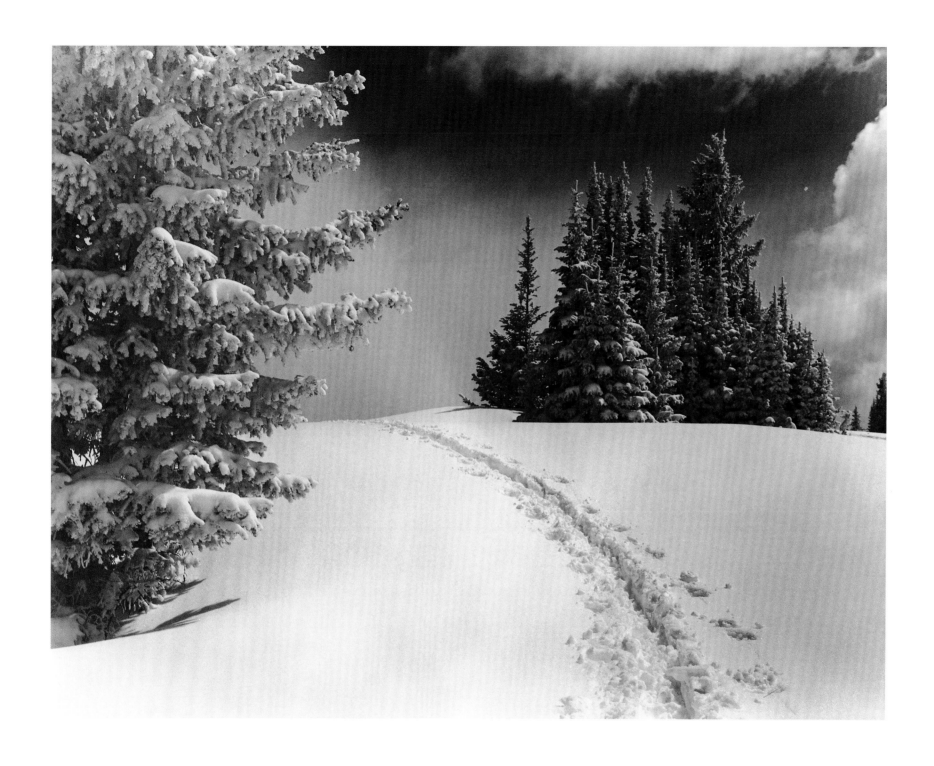

21 *Ski Trail on Aspen Mountain, 1949*

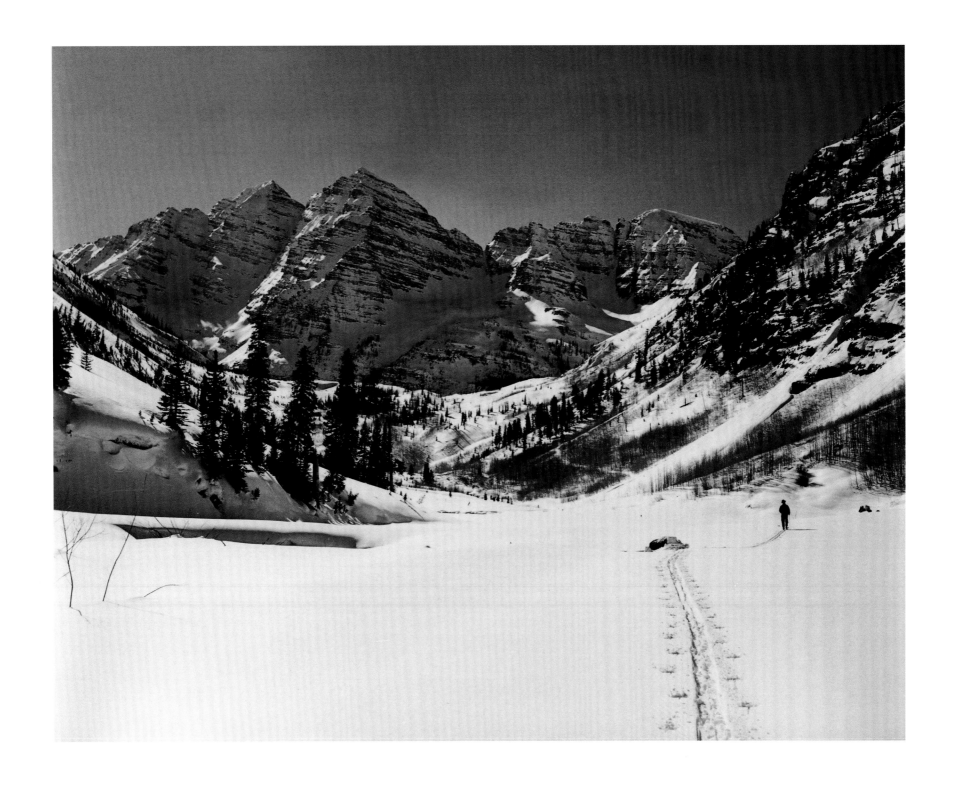

22 *Mike Magnifico at Maroon Bells, 1943*

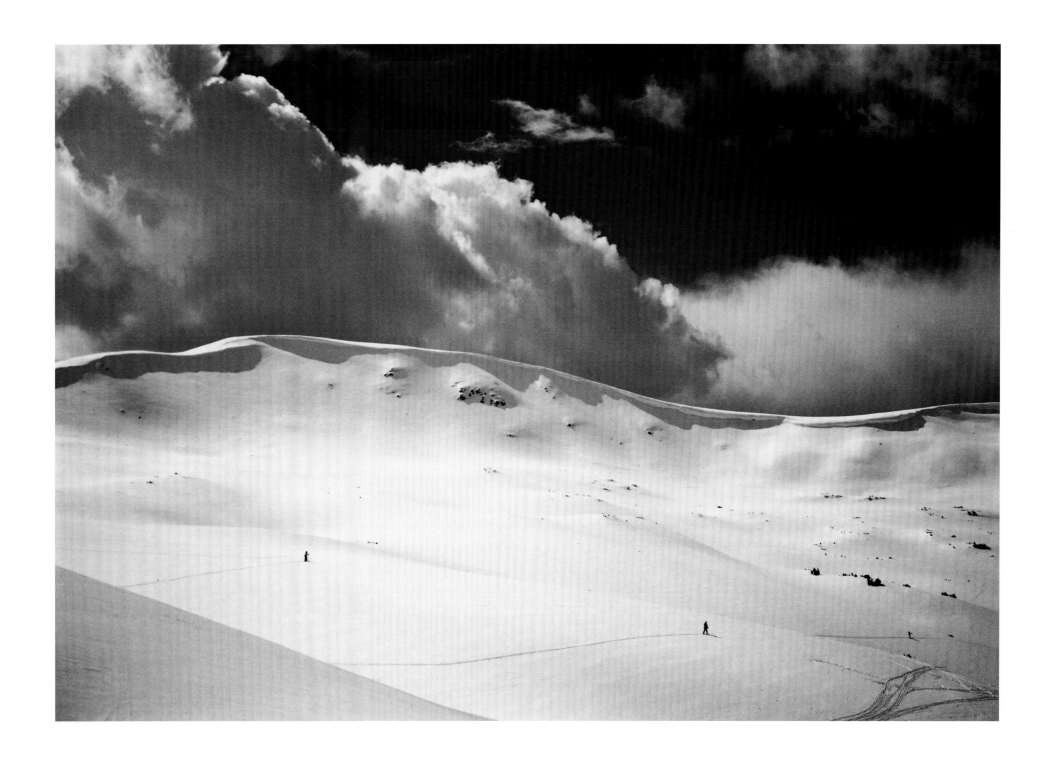

23 *Aspen Slopes, circa 1950*

LANDSCAPE: MAROON BELLS

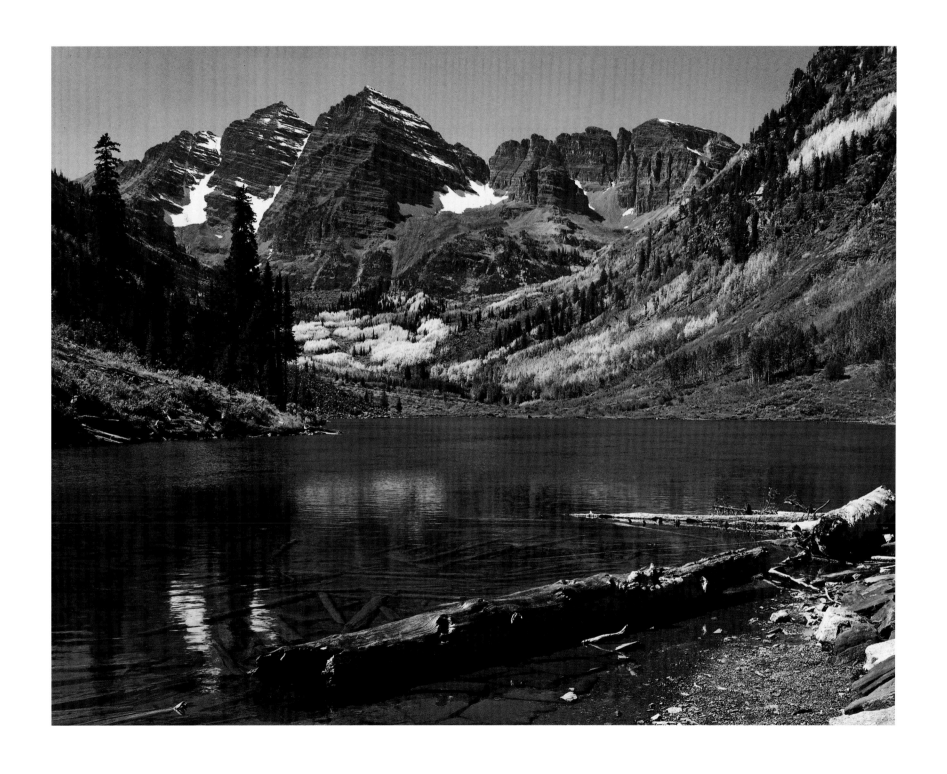

24 *Maroon Bells and Lake, Aspen, Colorado, 1952*

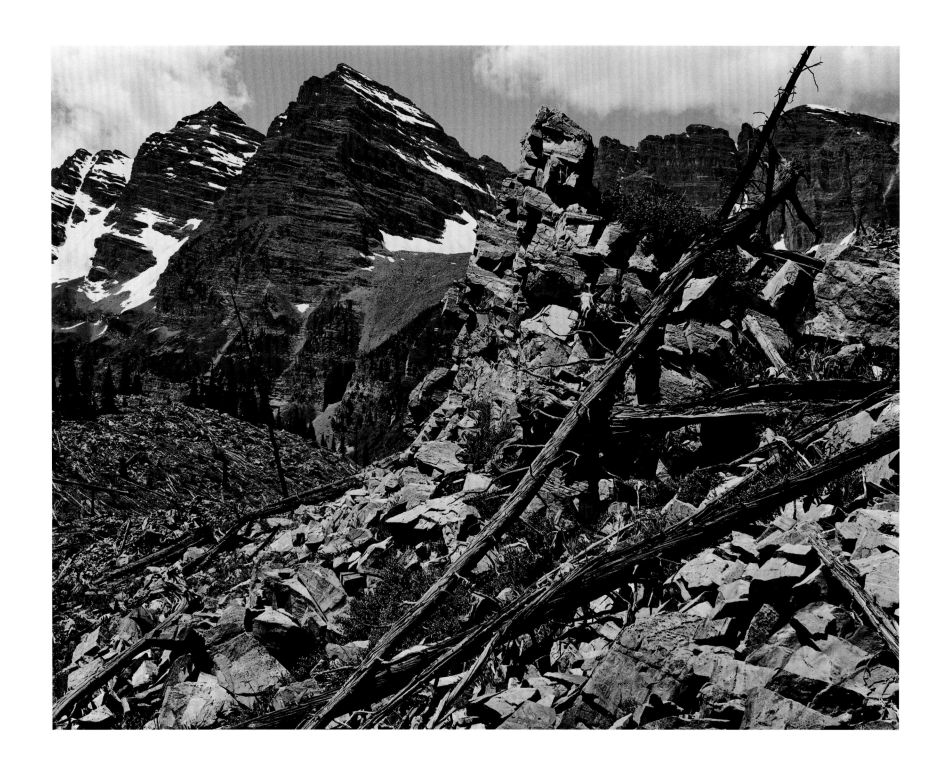

25 *Maroon Peaks and Rocks, 1949*

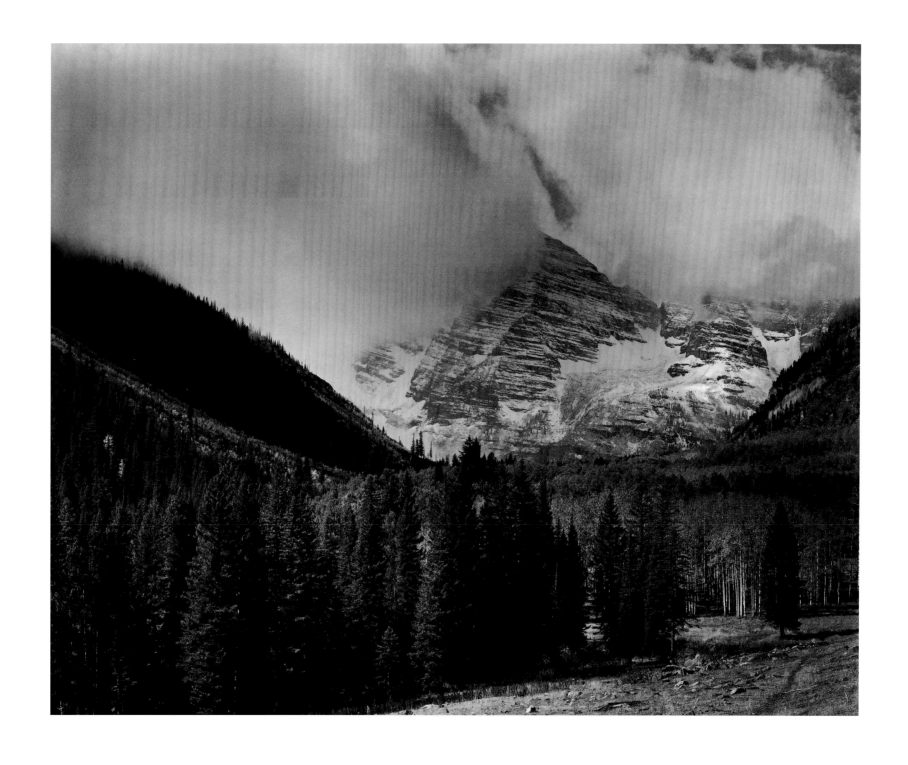

26 *Maroon Bells, Cloudy, 1951*

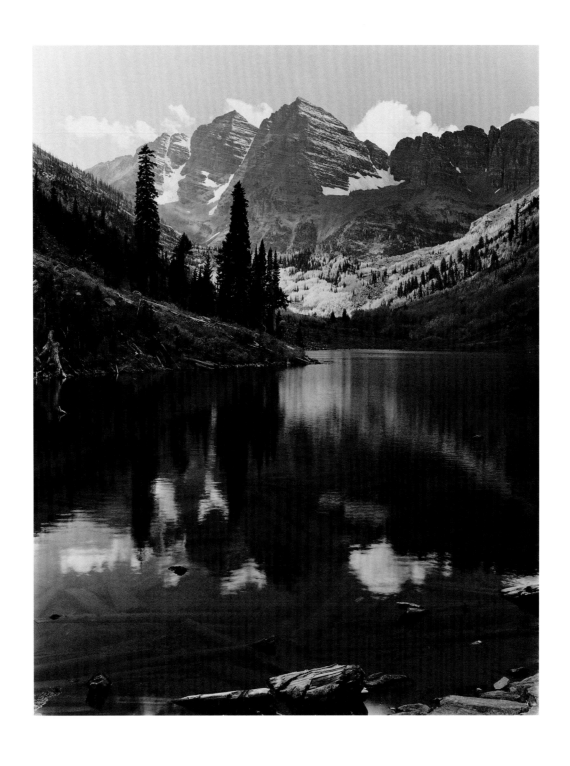

27 *Maroon Bells, 1949*

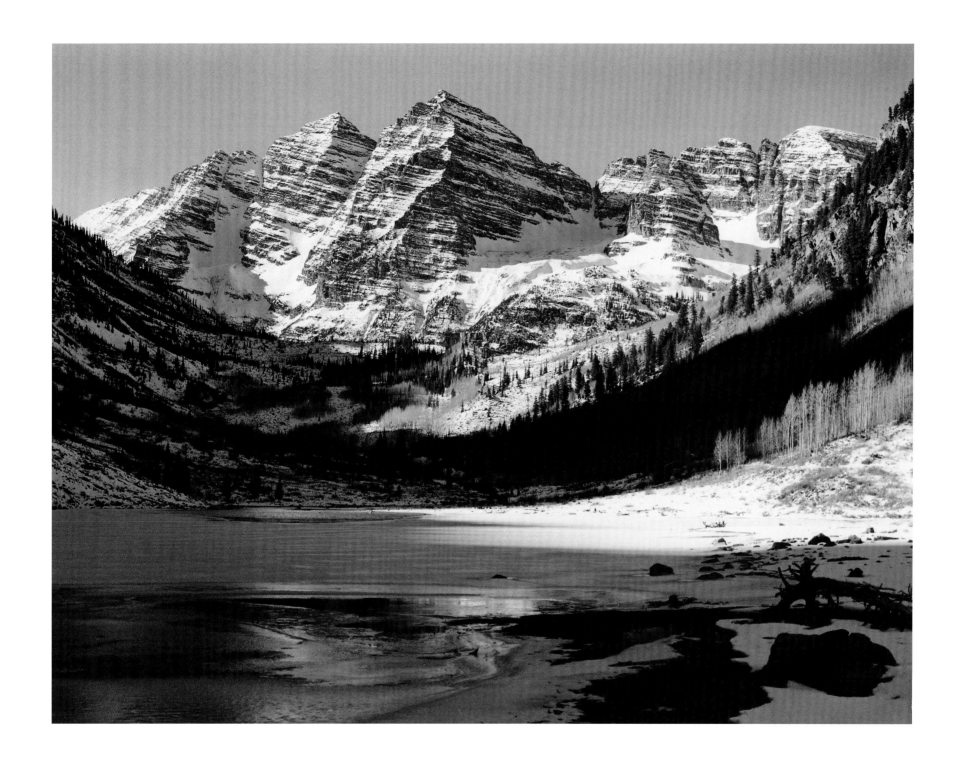

28 *Maroon Bells, Winter, 1949*

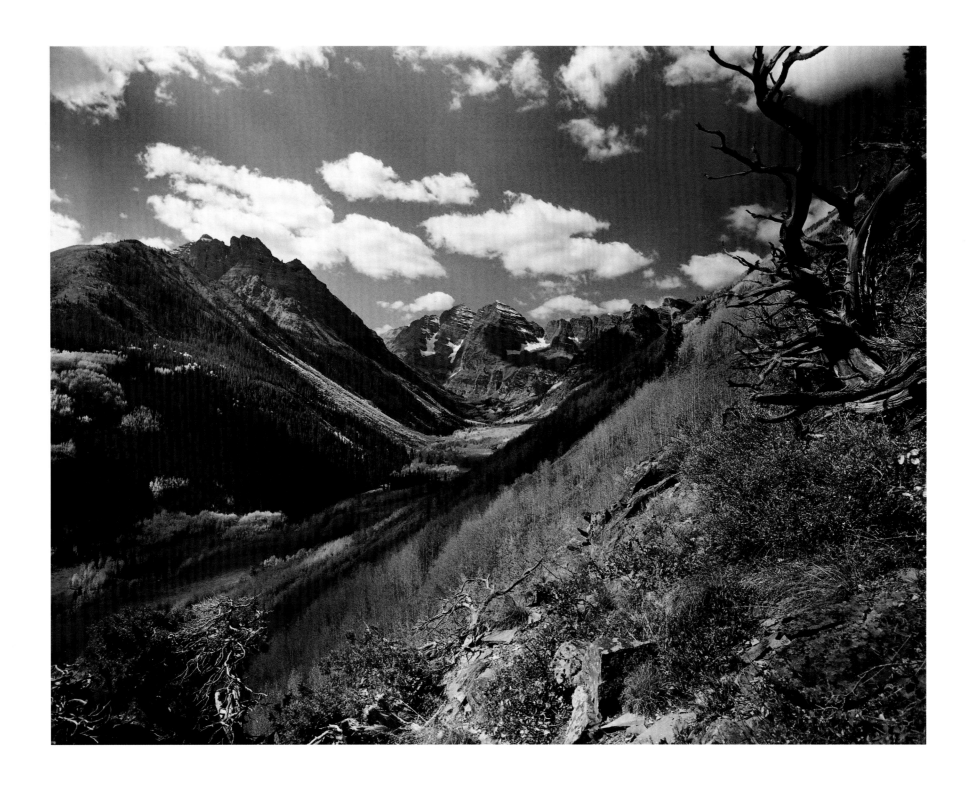

29 *Maroon Bells, 1948*

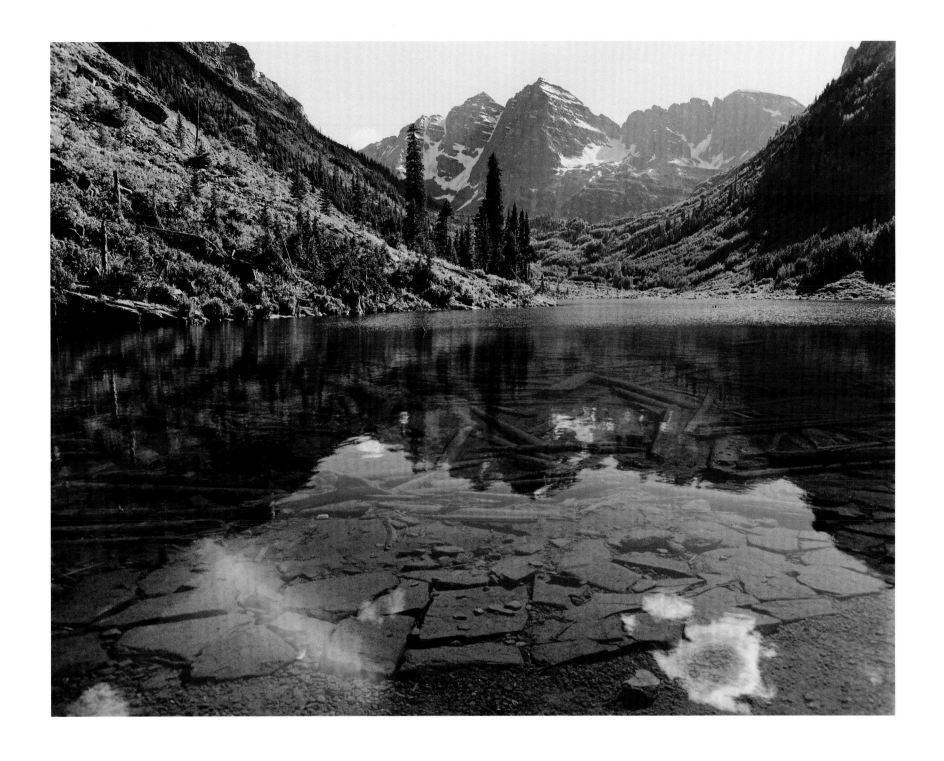

30 *Maroon Lake, 1951*

LANDSCAPE: MOUNTAINS & DESERT

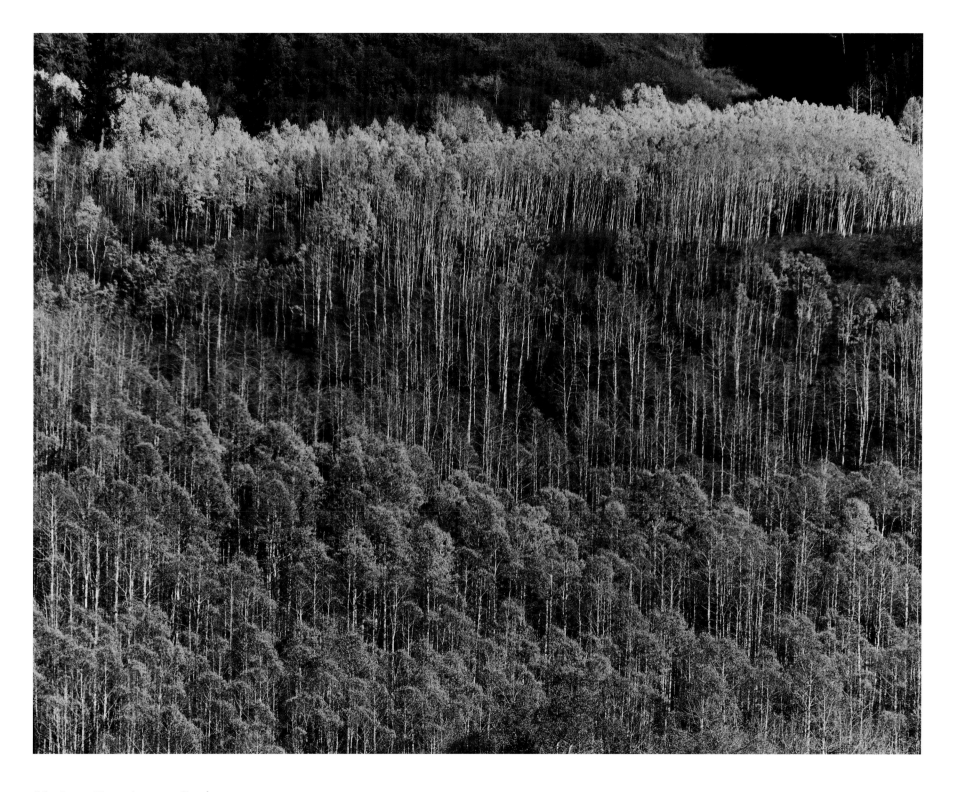

31 *Aspen Trees, Autumn, October 1950*

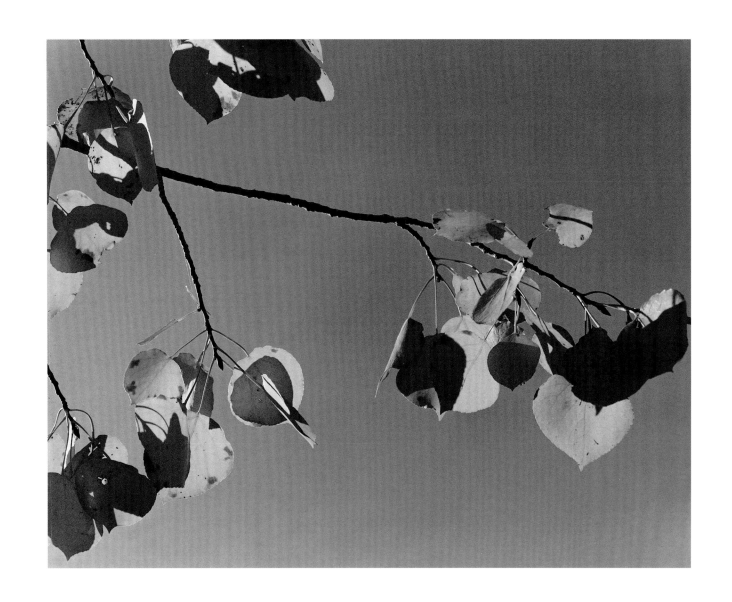

32 *Aspen Leaves, 1952*

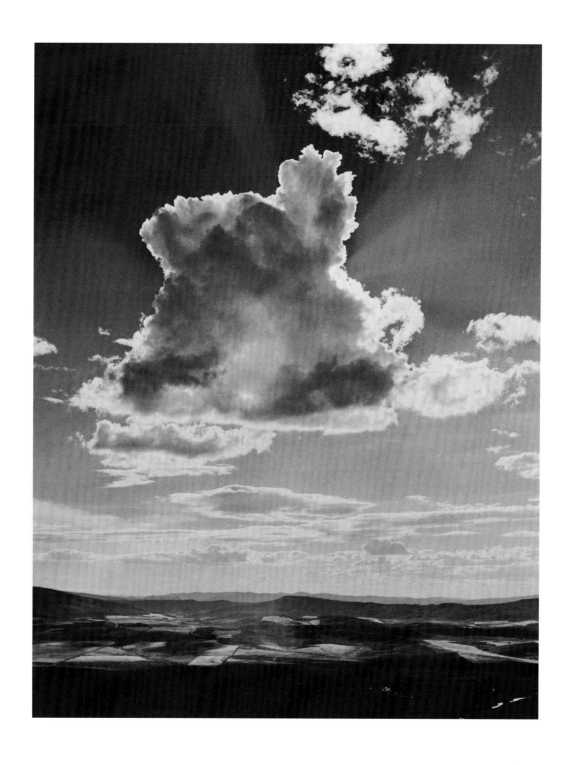

33 *Yampa Valley, Colorado, 1940*

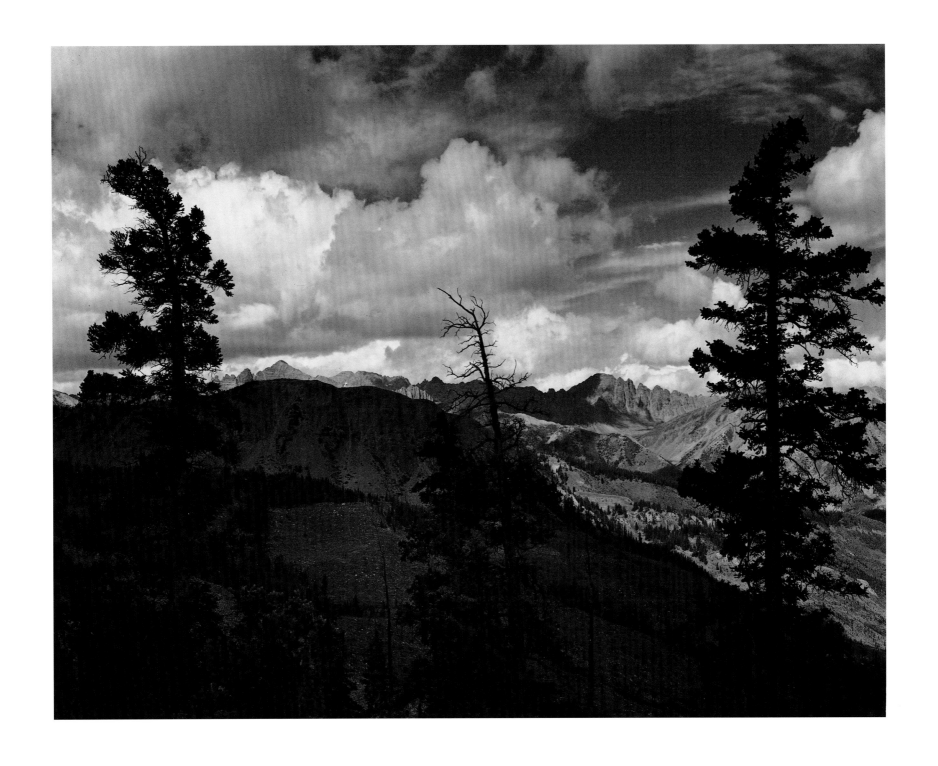

34 *Castle and Cathedral Peaks, Colorado, 1954*

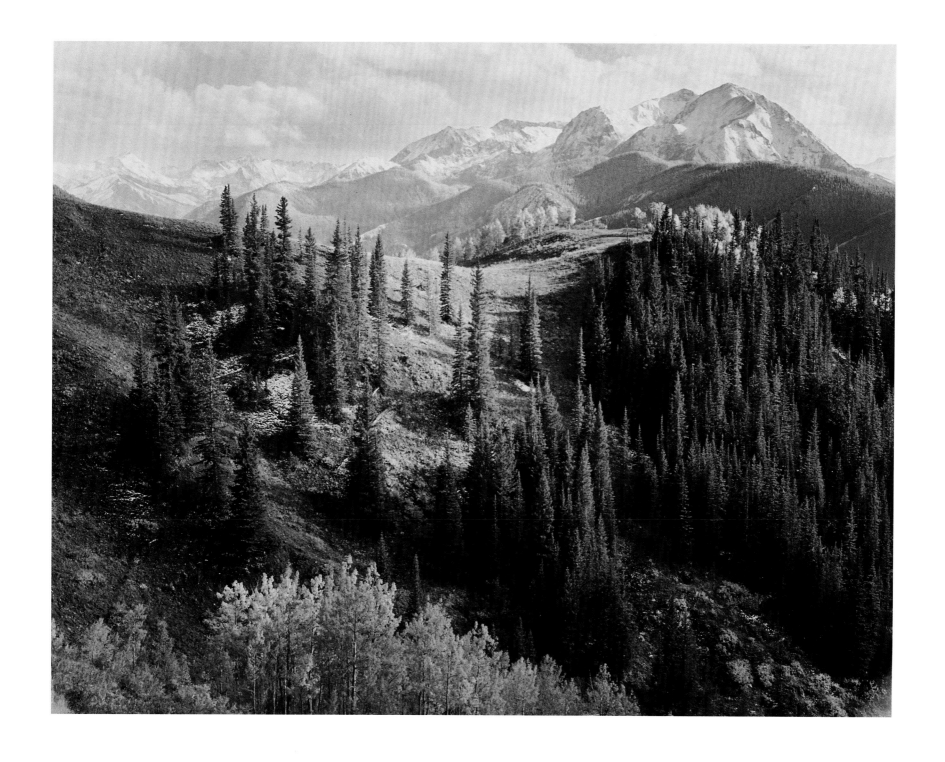

35 *Untitled (Colorado), 1940s*

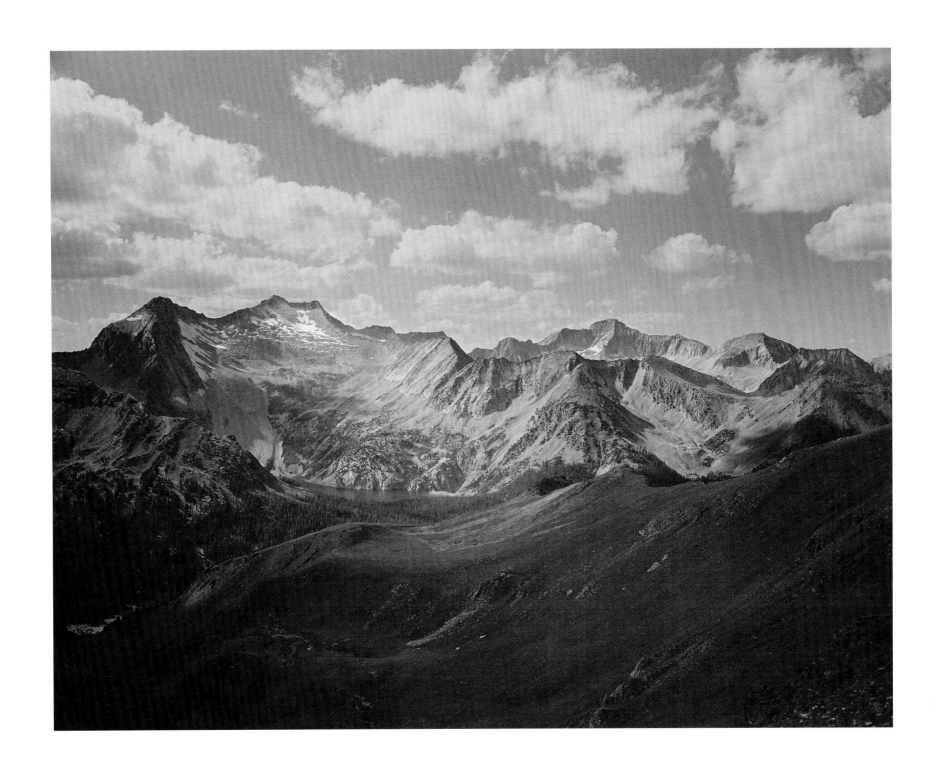

36 *Snowmass Lake, Pitkin County, Aspen, 1940s*

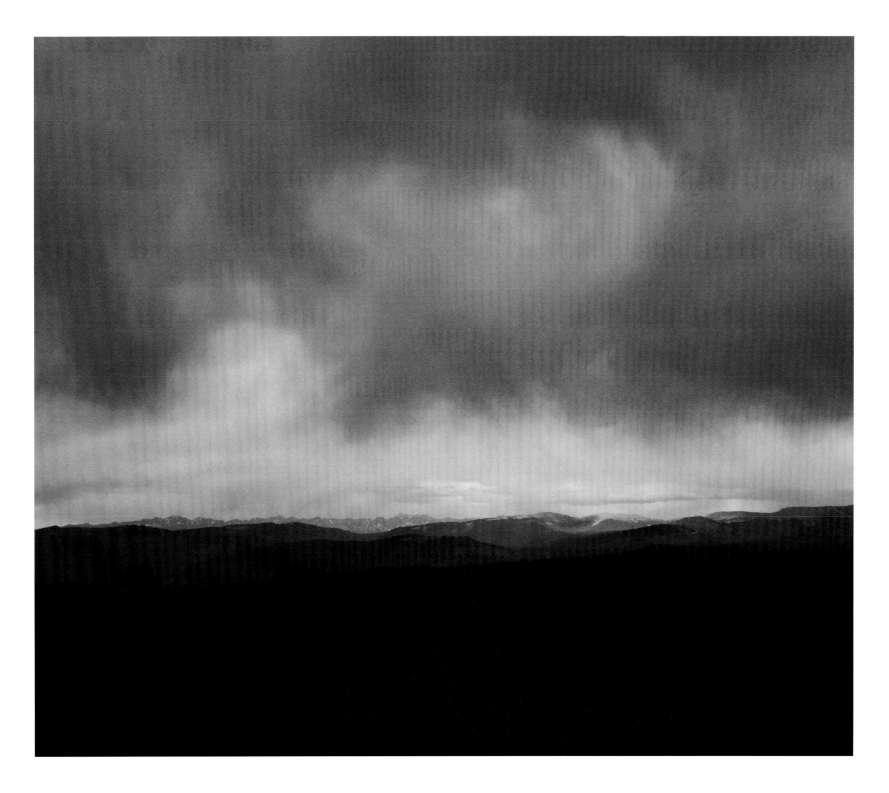

37 *Mountain Storm, 1951*

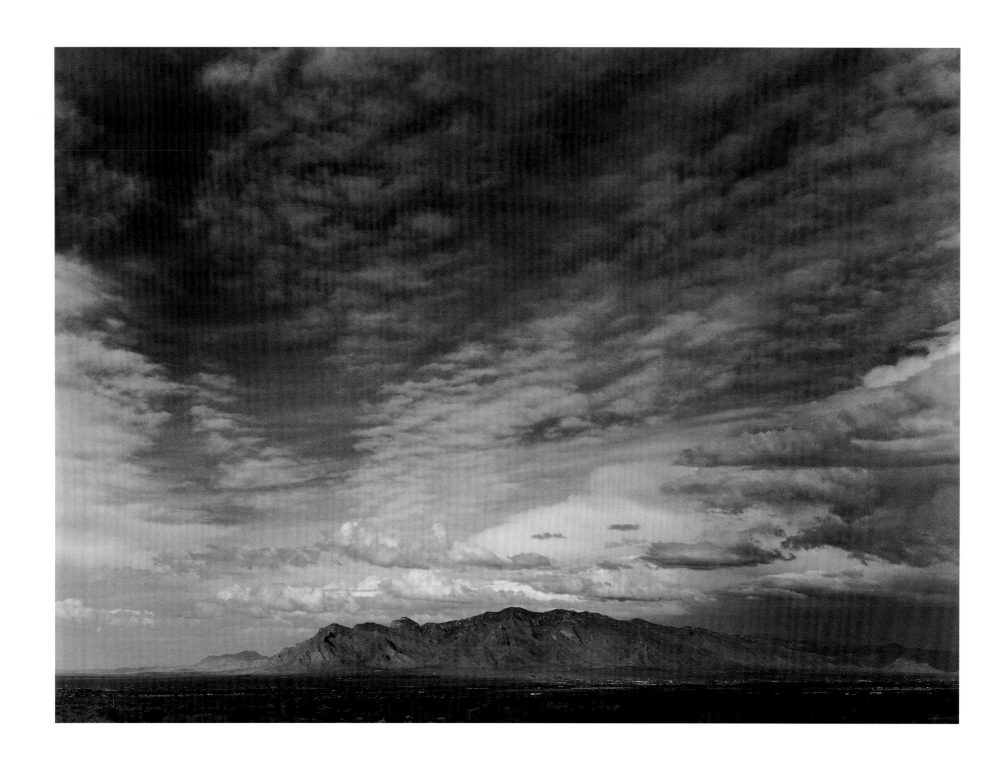

38 *Mount Lemon and Tucson, 1950s*

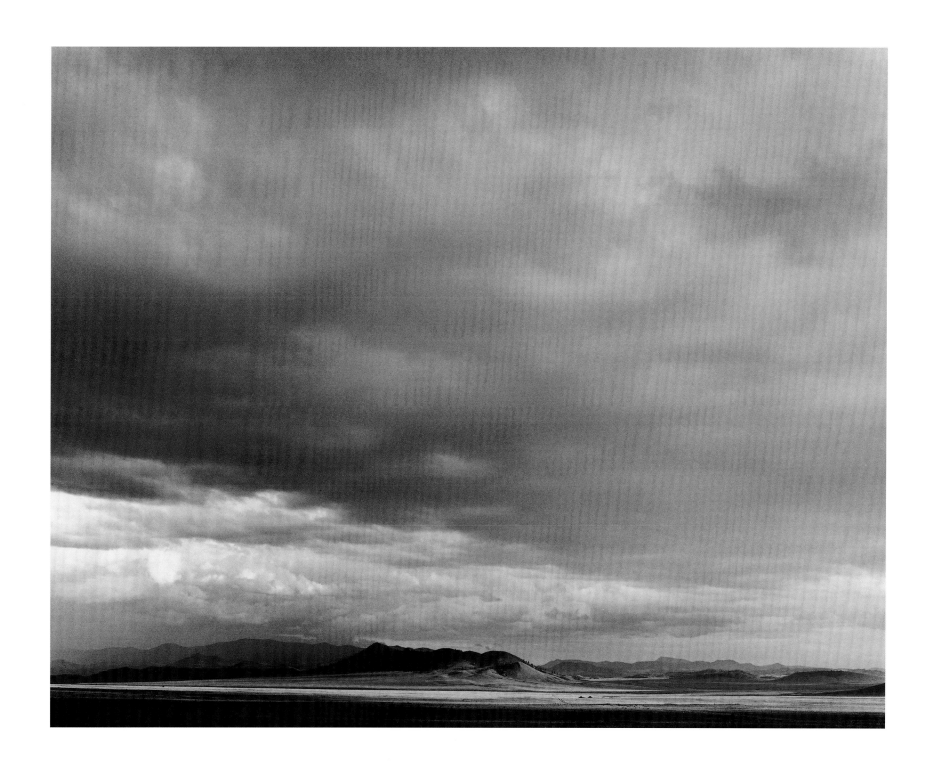

39 *Untitled (Desert and Sky), 1950s*

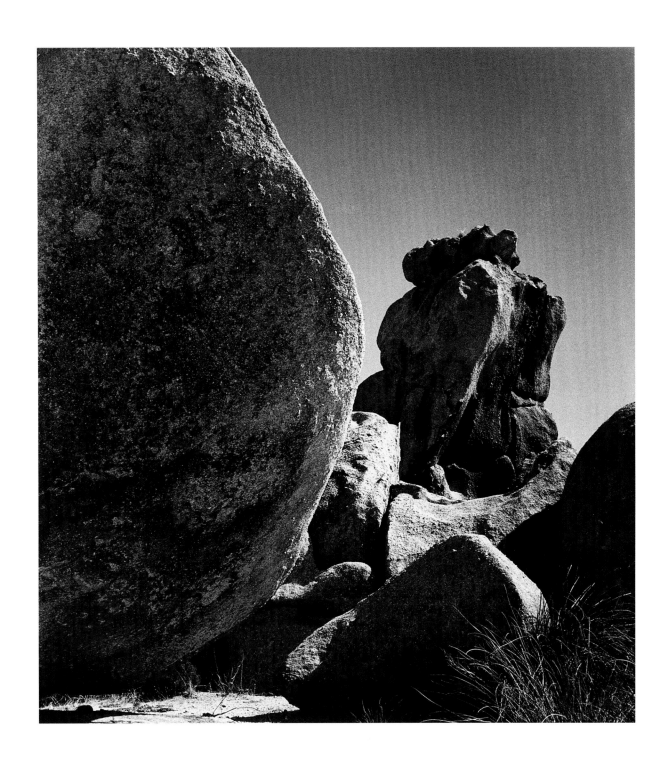

40 *Texas Canyon No. 4, 1955*

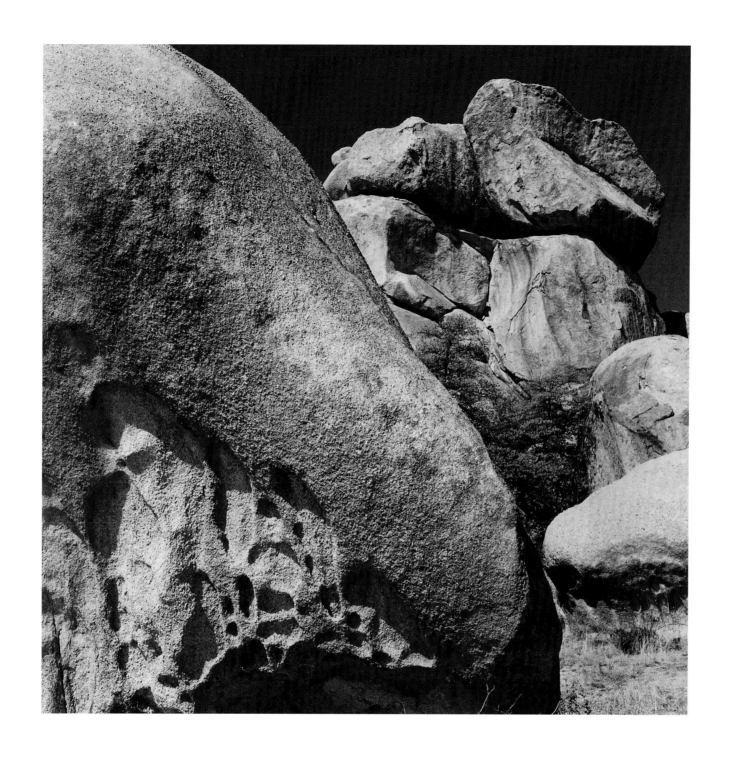

41 *Texas Canyon No. 5, 1955*

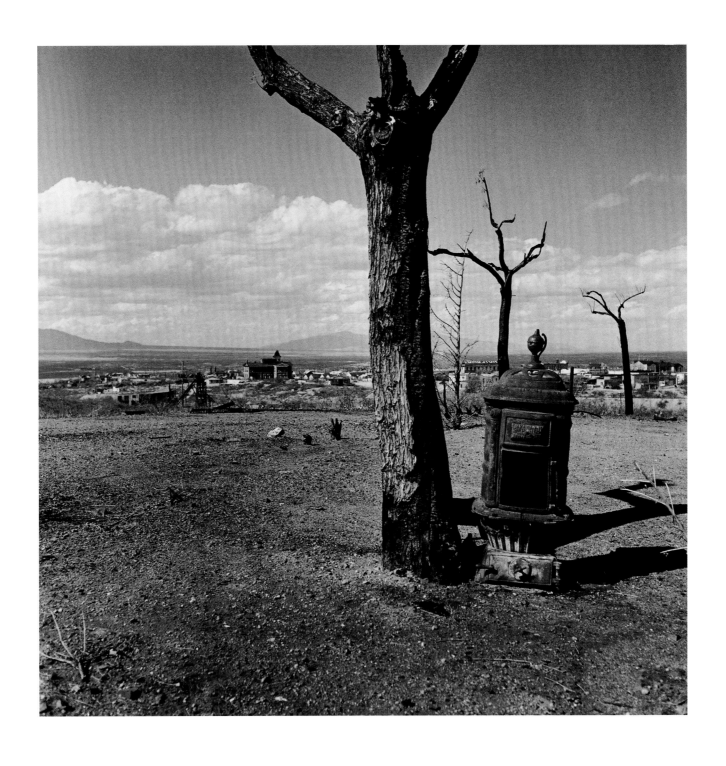

42 *Tombstone, Arizona, 1954*

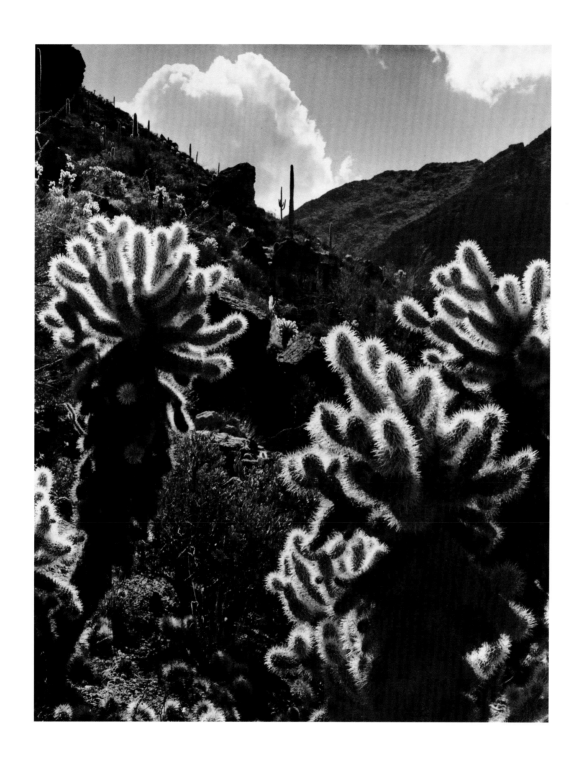

43 *Cholla Landscape, 1951*

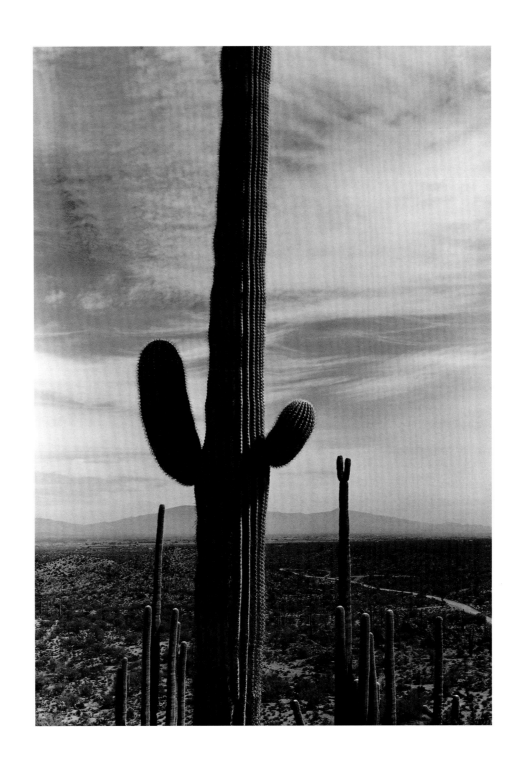

44 *Saguaro*, 1953

45 *Cholla and Saguaro, 1954*

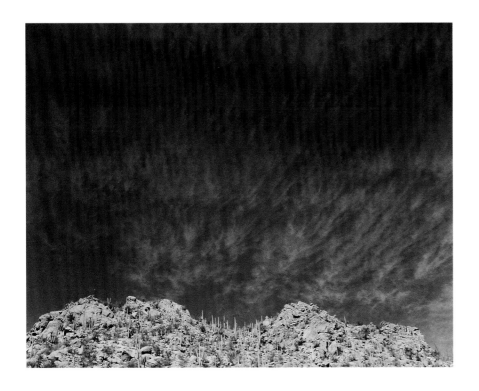

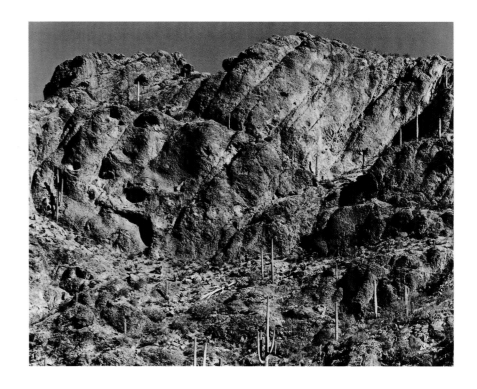

46 *Untitled (Clouds Over Hills), 1950s*
actual size

47 *Untitled (Hills and Cacti), 1950s*
actual size

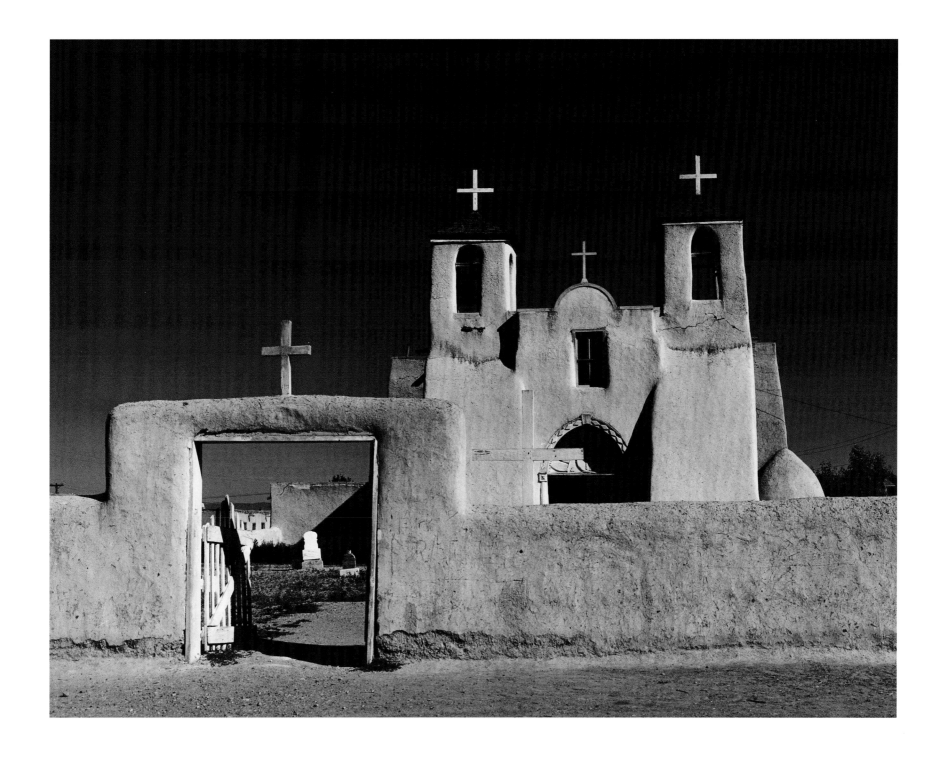

48 *Ranchos De Taos Mission, St. Francis of Assisi Parish, 1942*

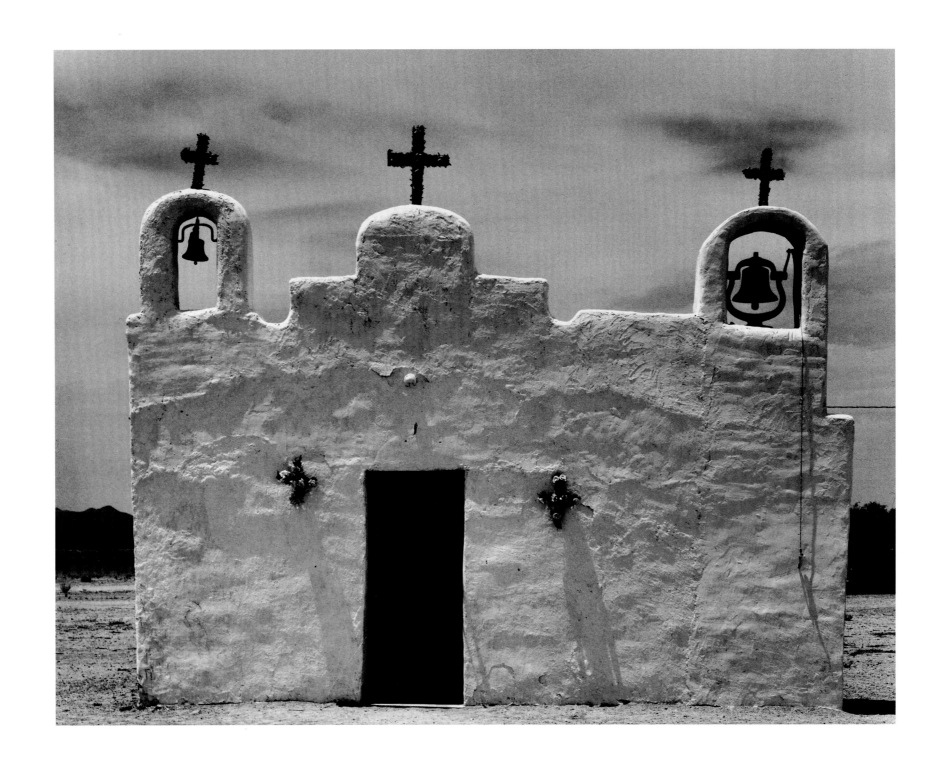

49 *Komelik, Papago Indian Village Church, 1963*

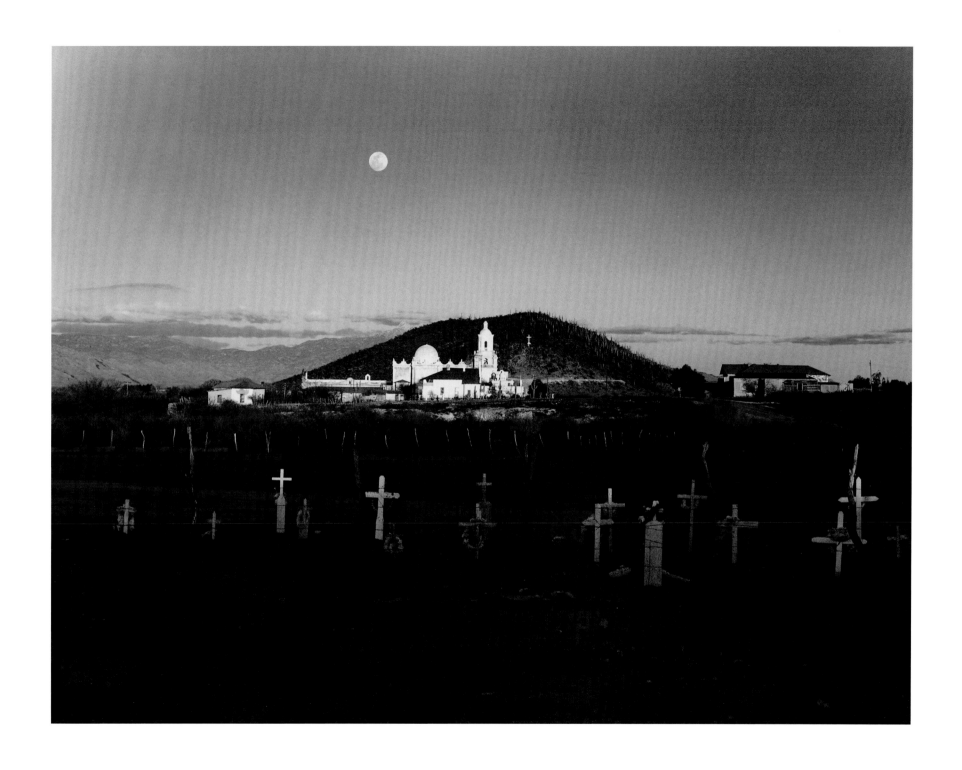

50 *San Xavier Moonrise, 1952*

 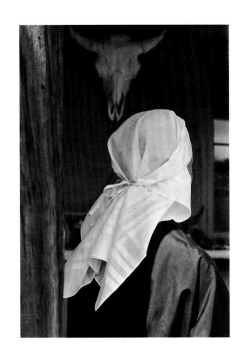 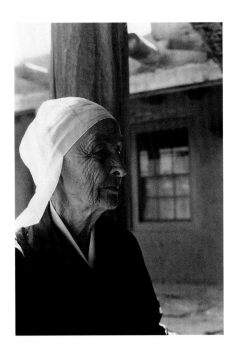 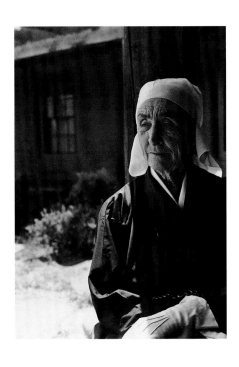

51 *Georgia O'Keeffe No. 4, 1968* 52 *Georgia O'Keeffe No. 8, 1968* 53 *Georgia O'Keeffe No. 10, 1968* 54 *Georgia O'Keeffe No. 12, 1968*

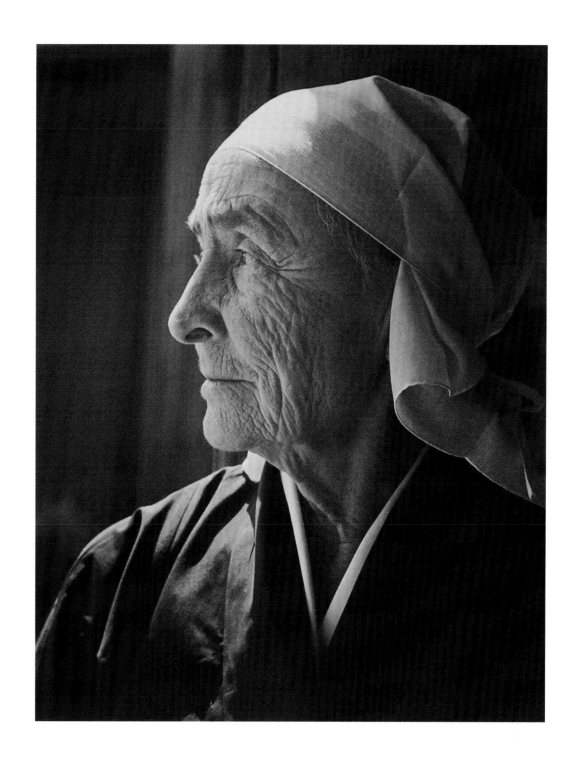

55 *Georgia O'Keeffe, 1968*

NATURE: FORM, TEXTURE, DESIGN

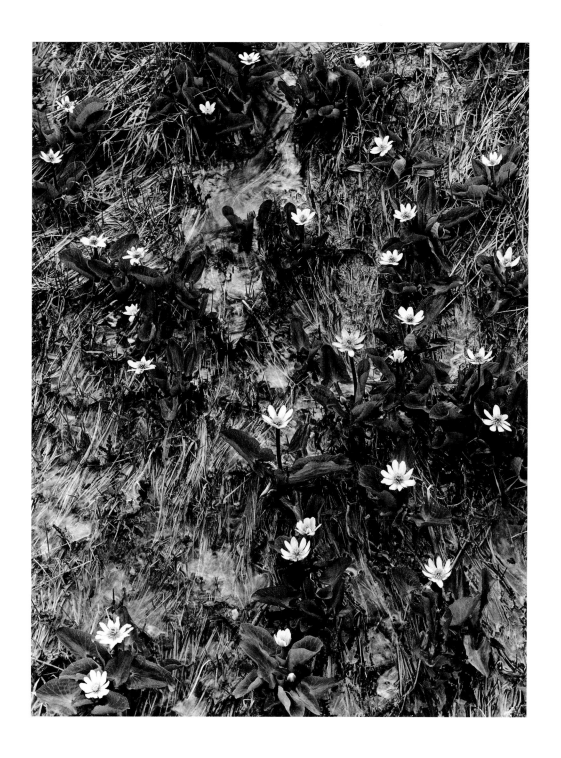

56 *Melting Snow, Praise the Lord, 1954*

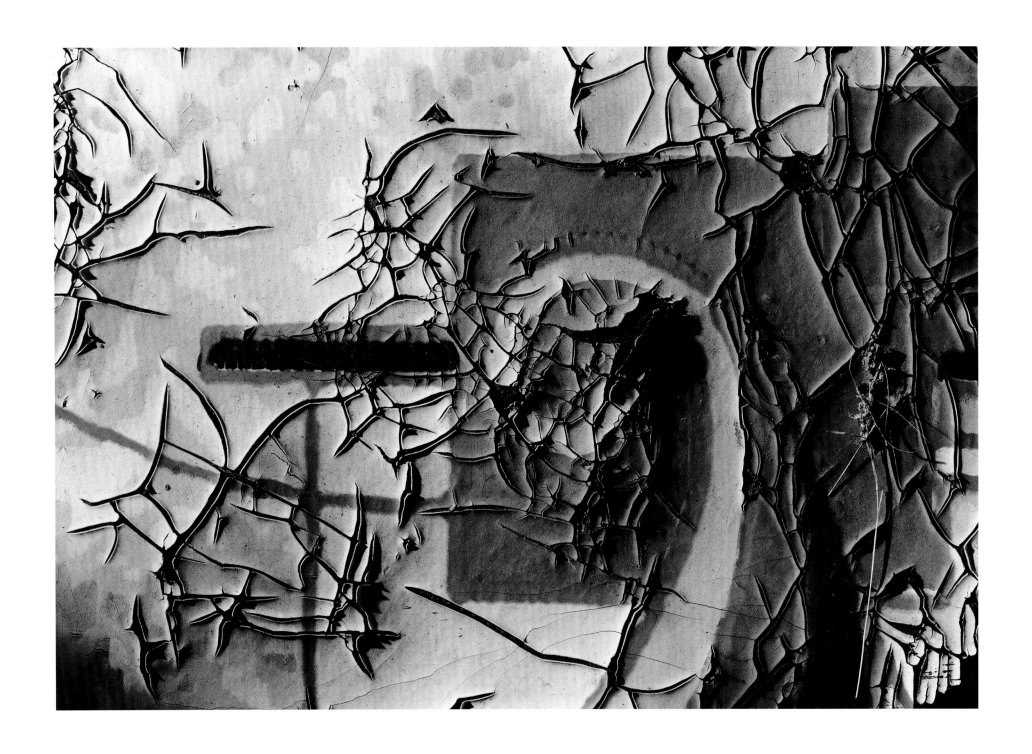

57 *Linoleum Texture from Old Mine Smelter, Sasco, 1953*

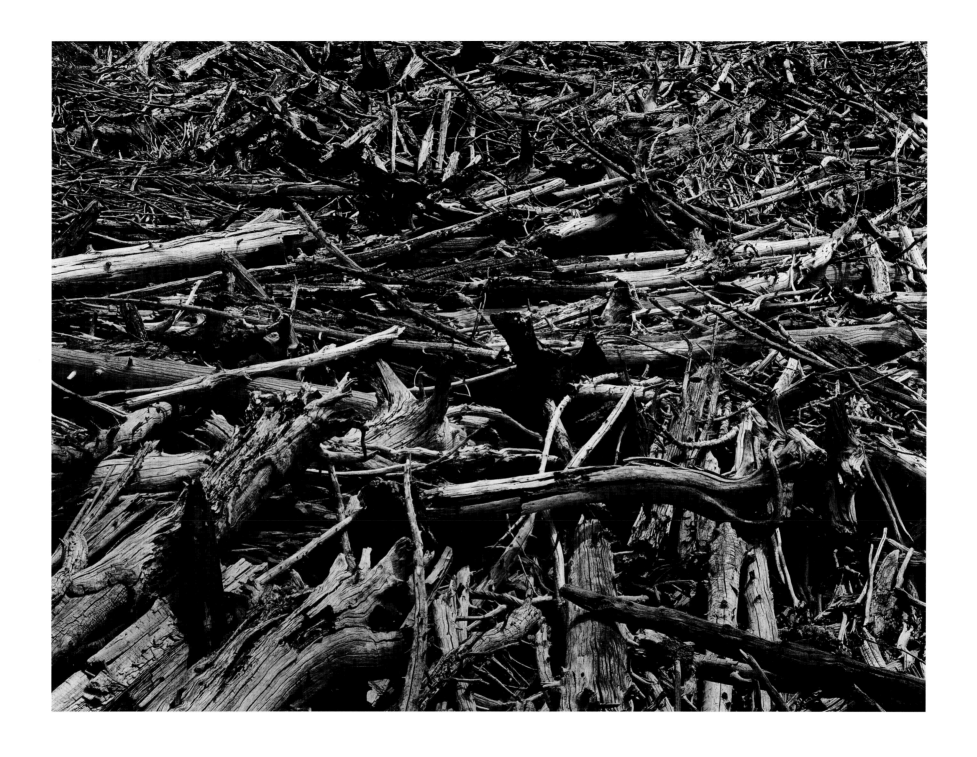

58 *Log Jam, 1953*

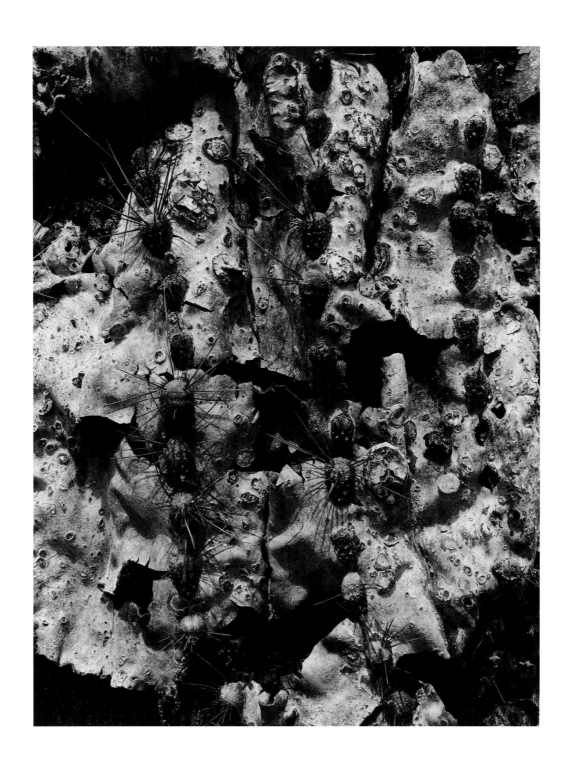

59 *Decaying Saguaro Close-up, 1953*

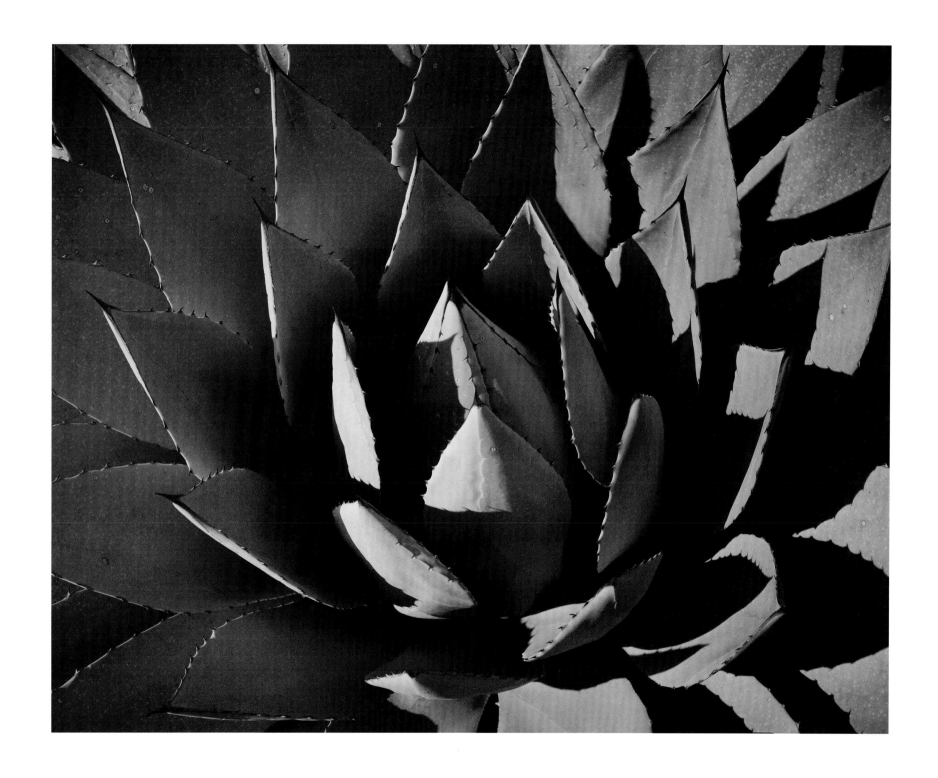

60 *Huachuca Agave, 1954*

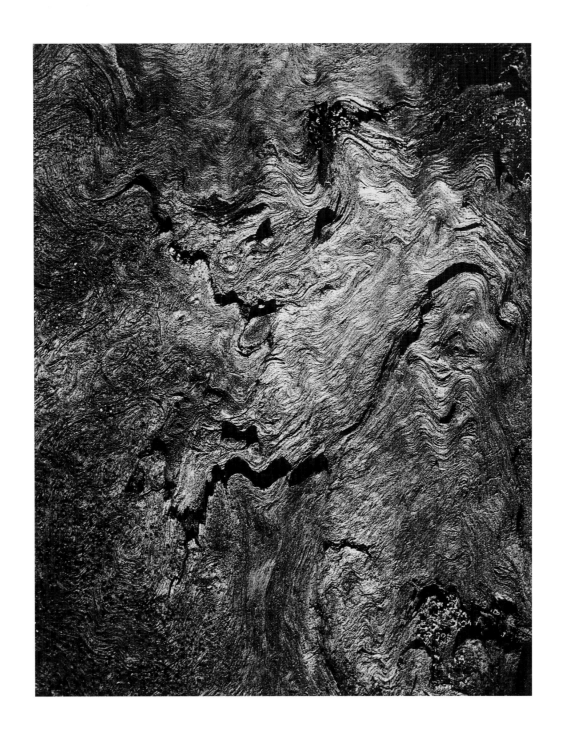

61 *Wood Texture Mountain Series No. 8, 1953*

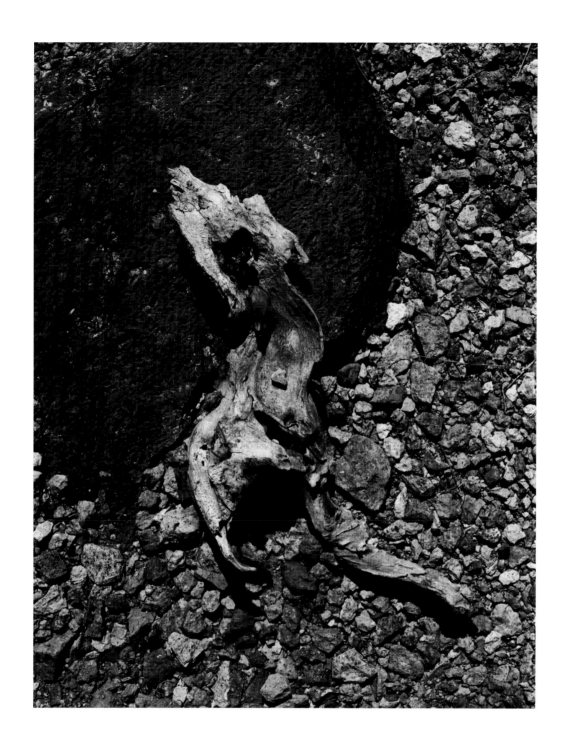

62 *Desert Form and Texture, 1950s*

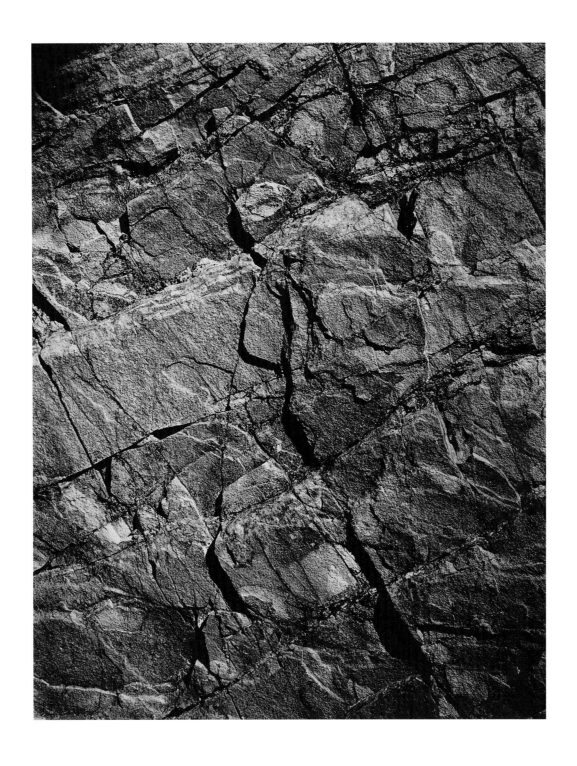

63 *Arizona Rock, 1950s*

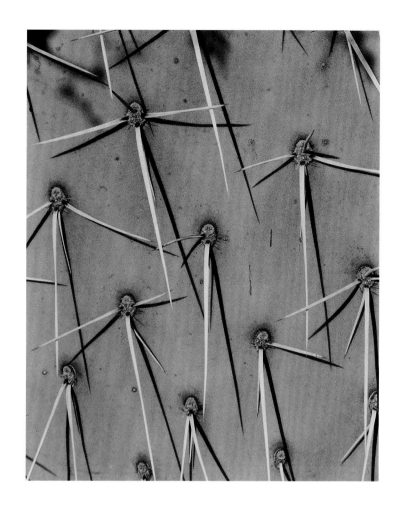

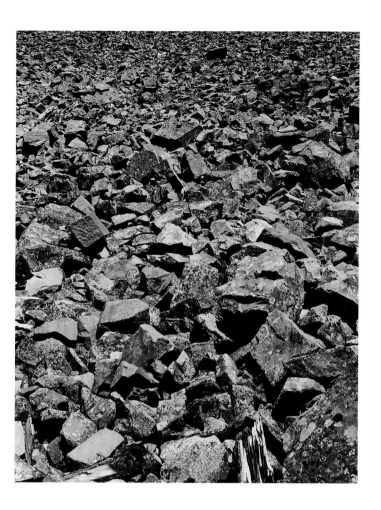

64 *Untitled (Cactus Spines), 1950s*
actual size

65 *Talus, 1952*
actual size

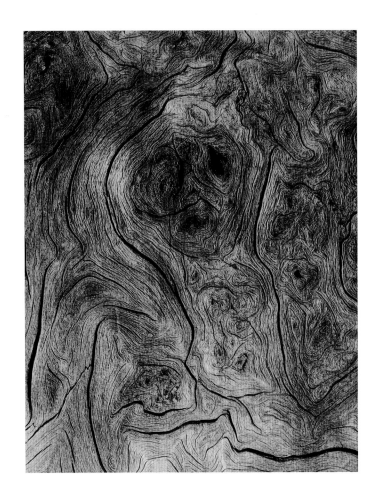

66 *Wood in Rain, 1953*
actual size

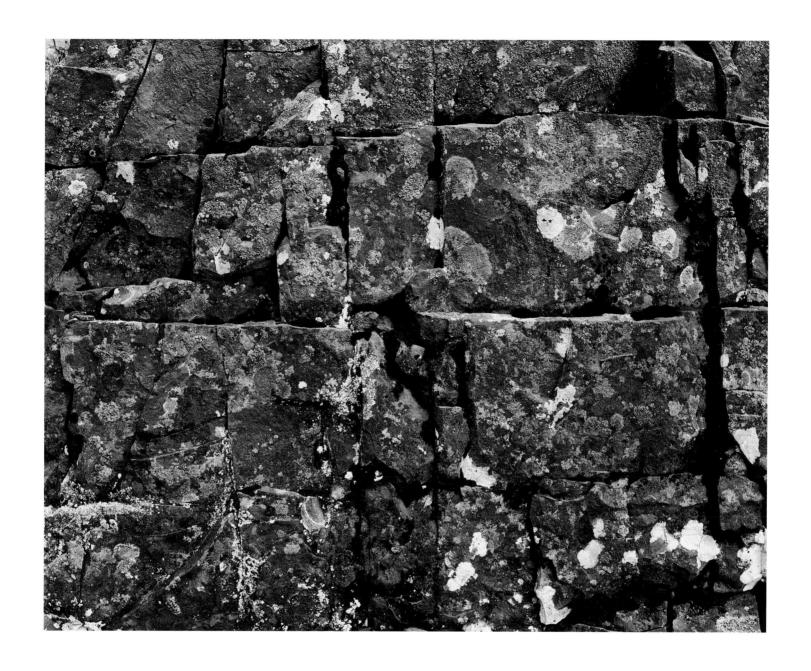

67 *Lichen Face, 1950s*

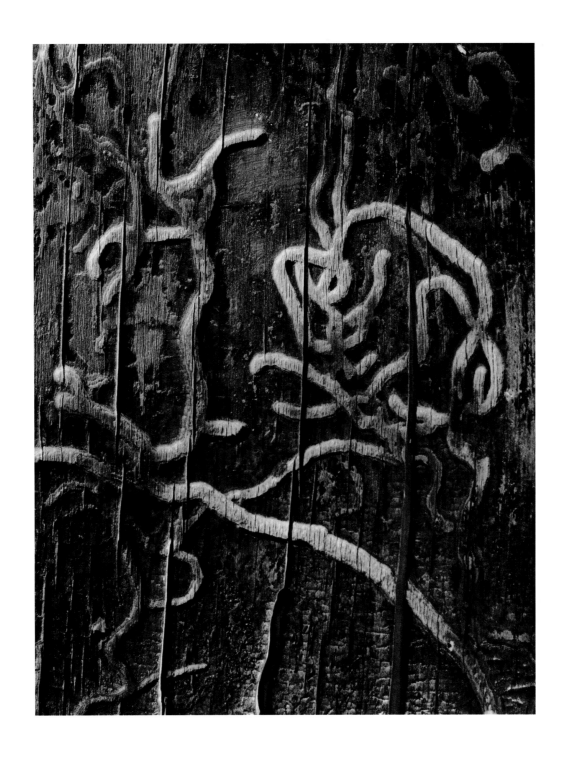

68 *Diagram by a Mountain Termite No. 1, 1961*

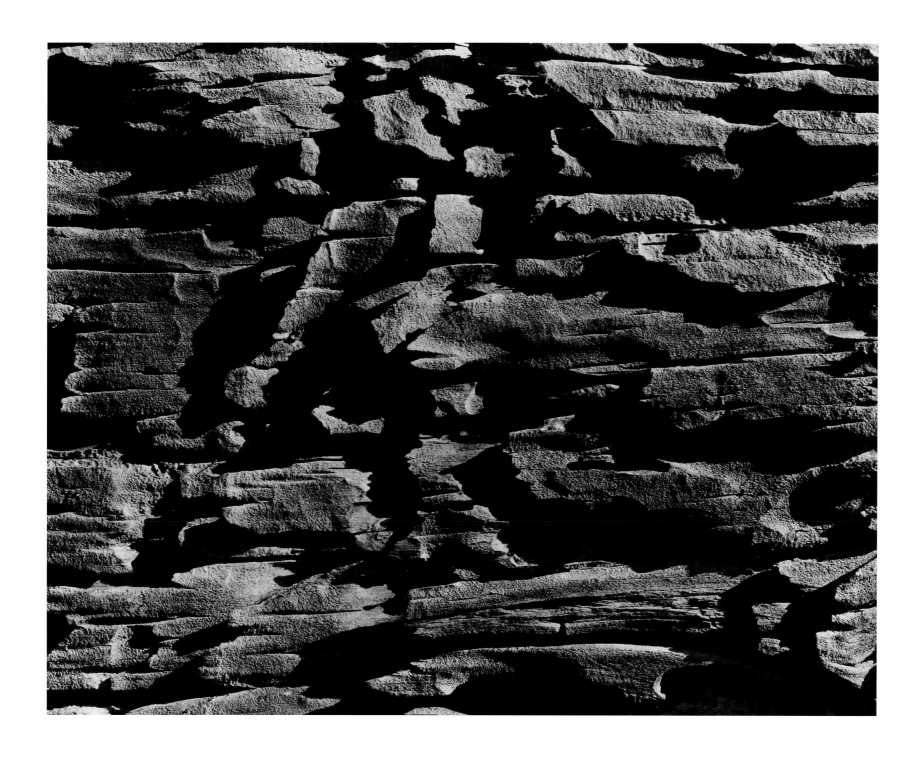

69 *Wood Texture B, 1969*

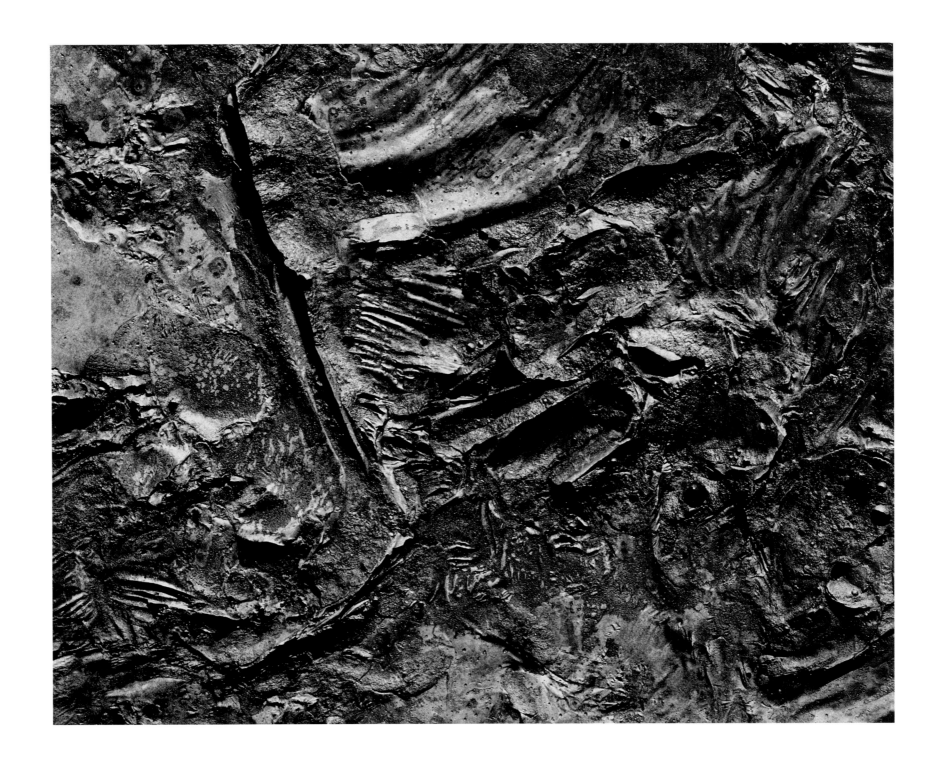

70 *Untitled (Slag, Sasco), 1960s*

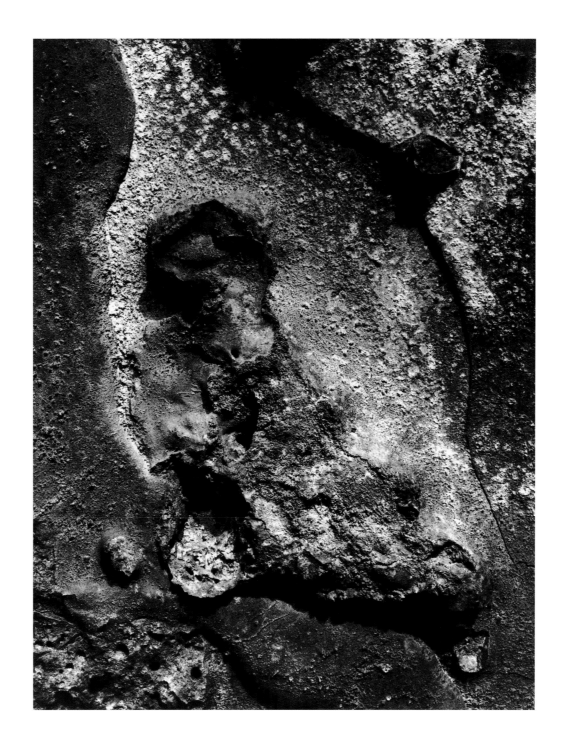

71 *Untitled, 1960s*

LATE WORK

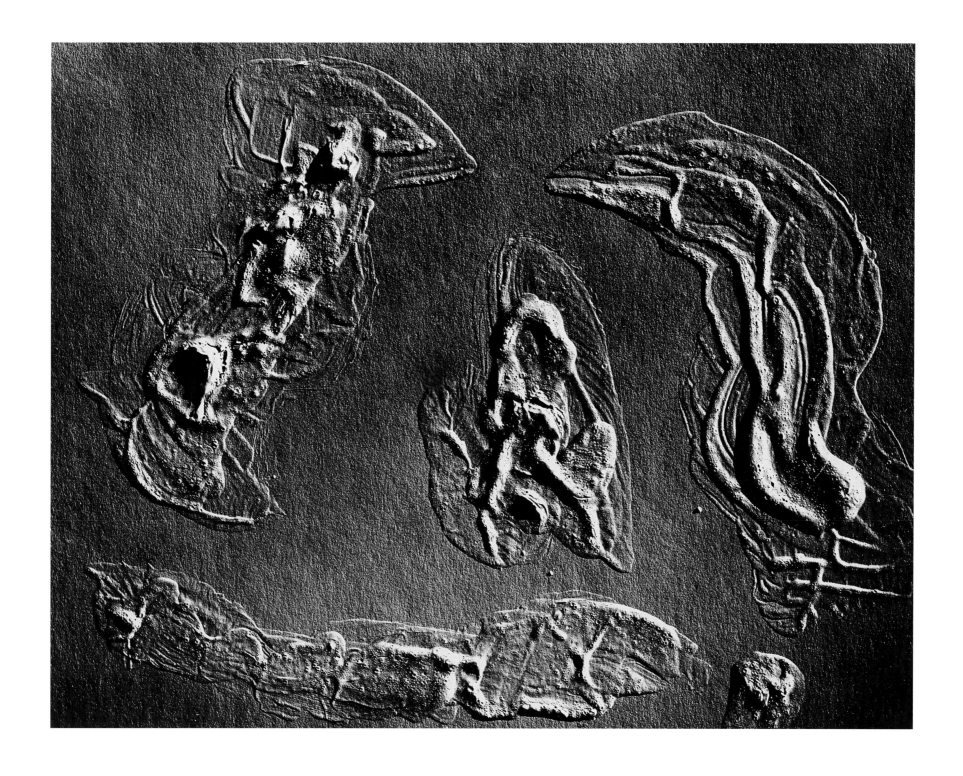

72 *Evolution*, 1977

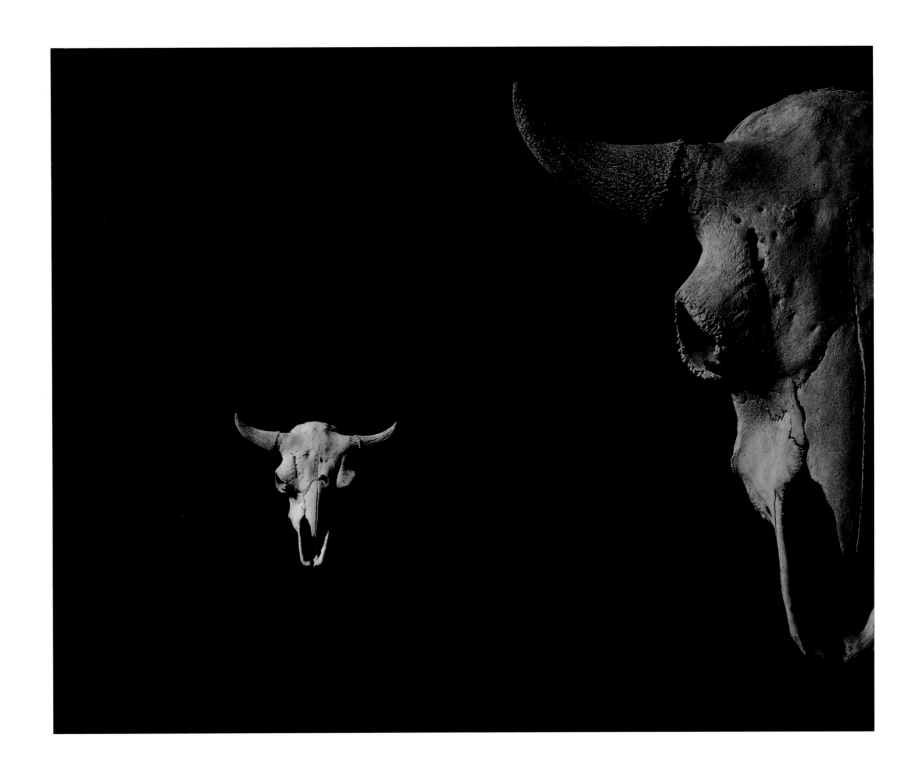

73 *Artifacts: Buffalo, 1981*

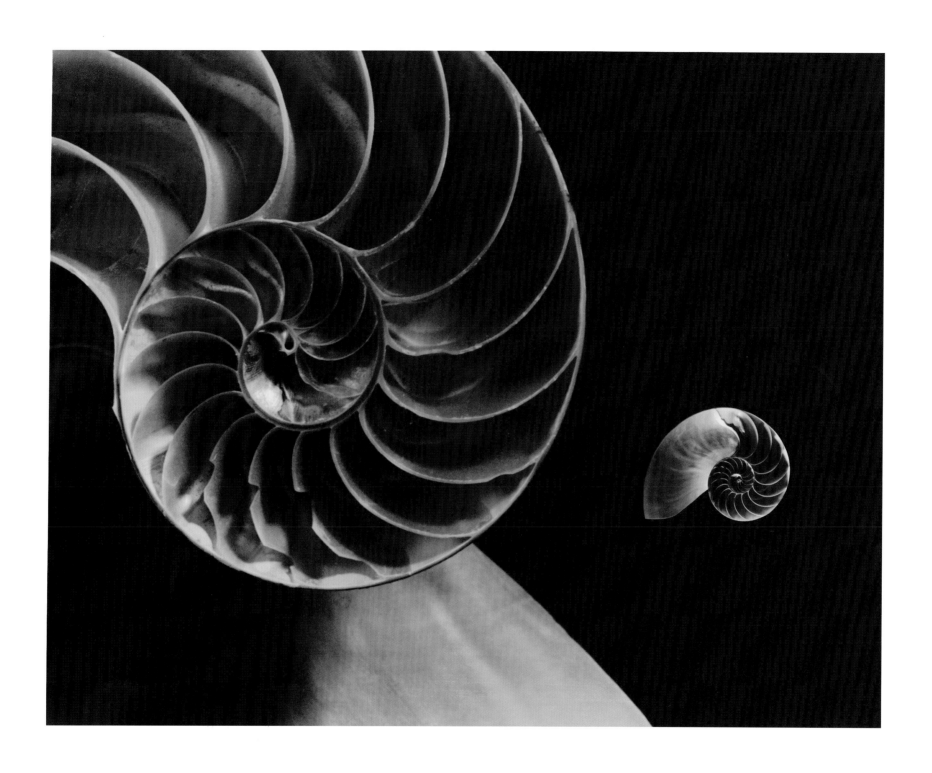

74 *Sea Shells, Chambered Nautilus, 1983*

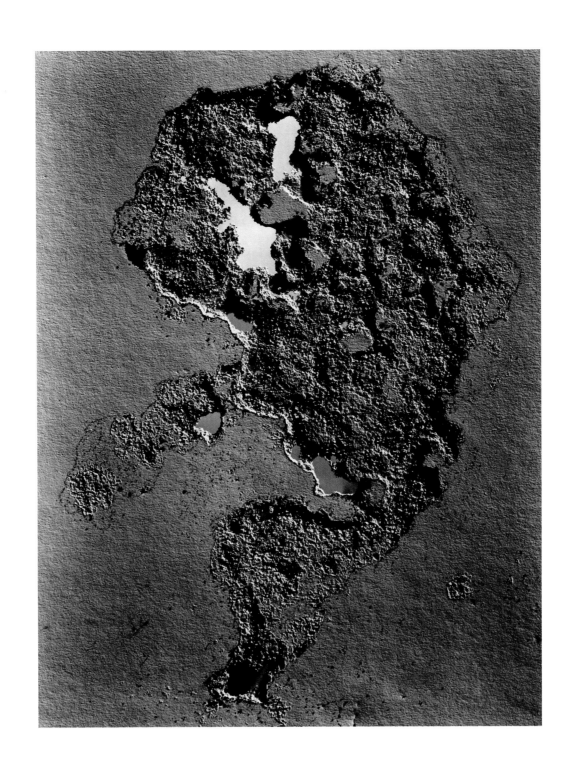

75 *Termite, 1980*

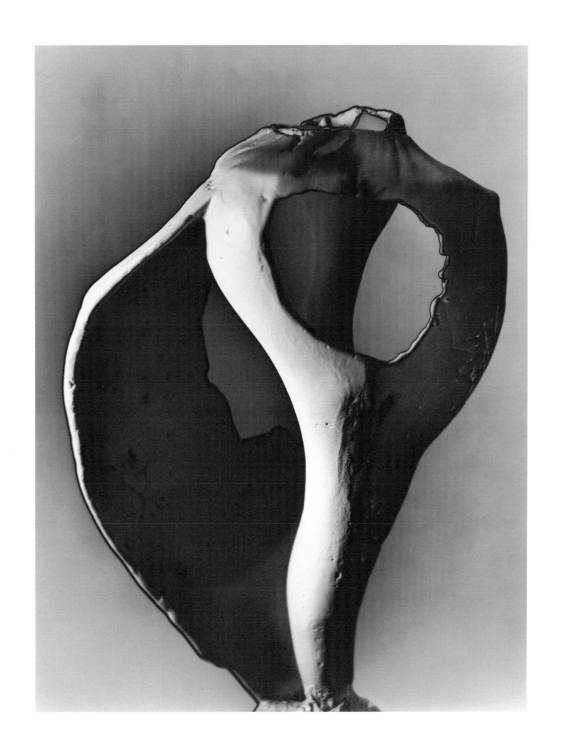

76 *Sea Shells, Eroded Sea Shell No. 10, 1983*

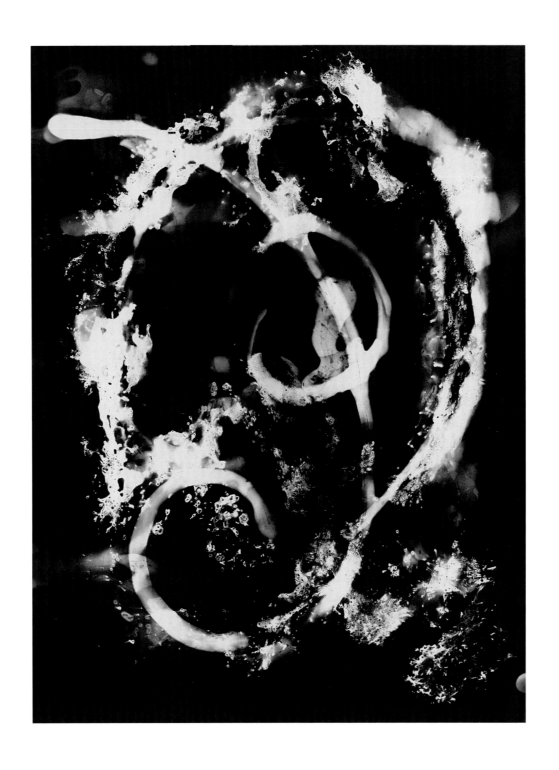

77 *Untitled (Painting on Film), 1970s*

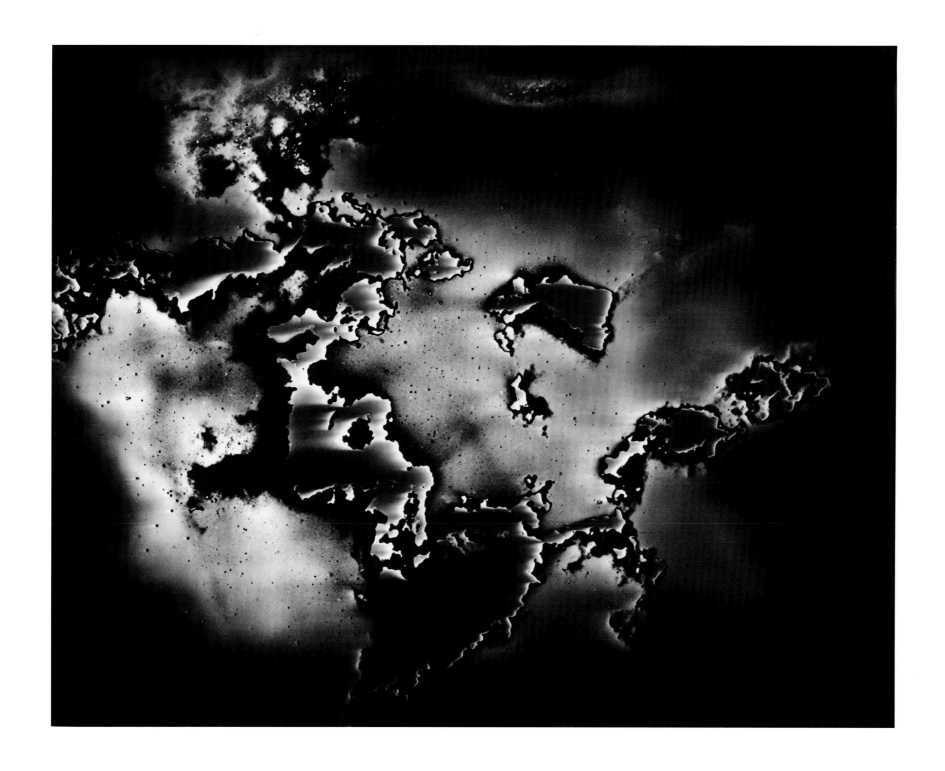

78 *Multi Solarization No. 10, 1979*

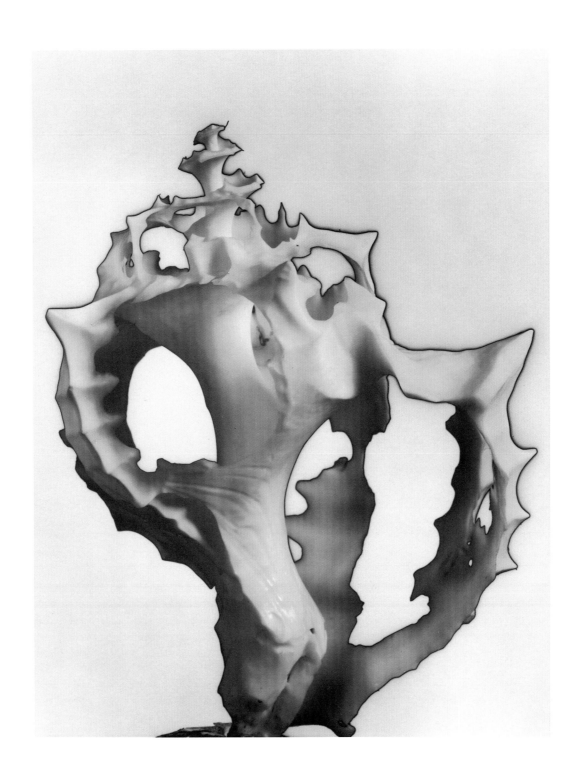

79 *Sea Shells, Eroded Sea Shell No. 12, 1983*

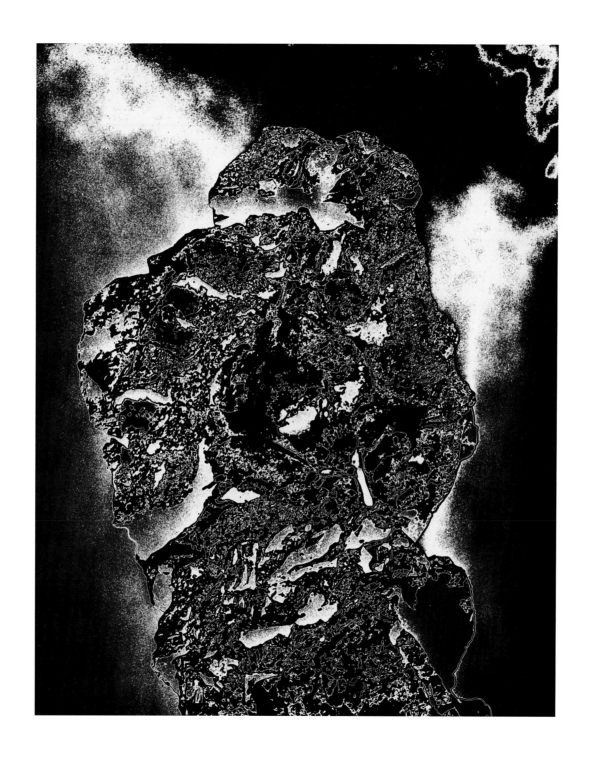

80 *Untitled, circa 1977*

LIST OF FIGURES & PLATES

NOTE TO THE CAPTIONS

When Fritz Kaeser reprinted many of his old negatives
in the late 1970s, he retroactively grouped all of his
photographs under broad categories that he called
"portfolios." For example, his early work was grouped
as "portfolio pictorial," the photographs of the
Maroon Bells were gathered together as "portfolio
landscape," and the nature close-ups might be
categorized as "texture," "form," "design," or with
a combination of these terms. Kaeser's portfolio
groupings are given in parentheses after the earlier titles.

All photographs are silver gelatin prints.

All photographs, unless noted otherwise,
belong to the collection of the Snite Museum of Art,
University of Notre Dame.

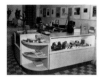

1 *Exterior of Fritz Kaeser's Madison Studio and Store, 1938*
Modern print from item 98
Fritz Kaeser Film Archives,
 University of Notre Dame
Gift of Milly Kaeser

2 *Interior of Fritz Kaeser's Madison Studio and Store, 1938*
Modern print from item 98
Fritz Kaeser Film Archives,
 University of Notre Dame
Gift of Milly Kaeser

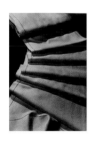

3 *Milly Kaeser Dance, "The Cat," Wisconsin Union Theater, 1941*
(Portfolio Pictorial)
11 x 14 in. (27.9 x 35.6 cm.)
82.87.12.l
Gift of Fritz Kaeser

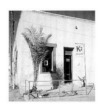

4 *Commercial Illustration of Toweling, circa 1937*
13 x 9.5 in. (33 x 24 cm.)
80.29.22
Gift of Fritz Kaeser

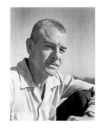

5 *Self-Portrait, Florence, Italy, 1945*
Modern print from item 817
Fritz Kaeser Film Archives,
 University of Notre Dame
Gift of Milly Kaeser

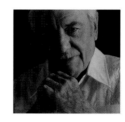

6 *K2 Studio, Aspen, 1952*
Color transparency, item 3288
Fritz Kaeser Film Archives,
 University of Notre Dame
Gift of Milly Kaeser

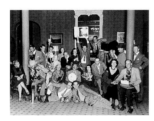

7 *Self-Portrait at Ashcroft, Colorado, 1941*
(Portfolio Portrait)
8 x 10 in. (20.3 x 25.4 cm.)
aa 97.41.01.S
Gift of Milly Kaeser

8 Bob Bishop, *Aspen Photographer's Conference, 1951*
Copyright © Robert C. Bishop
Courtesy of the Center for
 Creative Photography, Tucson

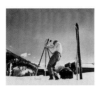

9 *K2 Studio, Tucson, 1954*
Color transparency, item 3085
Fritz Kaeser Film Archives,
 University of Notre Dame
Gift of Milly Kaeser

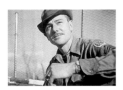

10 *Self-Portrait, 1955*
Modern print from item 3961
Fritz Kaeser Film Archives,
 University of Notre Dame
Gift of Milly Kaeser

11 *Dorothy Day, 1958*
(Portfolio Pictorial)
14 x 11 in. (35.6 x 27.9 cm.)
82.87.12.L
Gift of Fritz Kaeser

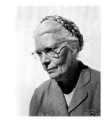

12 José Luis Villegas, *Fritz Kaeser, 1985*
Copyright © *Arizona Daily Star*

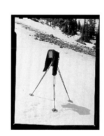

13 *Chapel, Desert House of Prayer, 1982*
Modern print from item 2963
Fritz Kaeser Film Archives,
 University of Notre Dame
Gift of Milly Kaeser

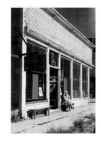

Fritz Kaeser's Snow Tripod, circa 1950
(Final image)
Modern print from item 3358
Fritz Kaeser Film Archives,
 University of Notre Dame
Gift of Milly Kaeser

1 *Frederick Kaeser II, Self-Portrait, 1934*
(Portfolio Pictorial)
12 x 10 in. (30.5 x 25.4 cm.)
80.29.32
Gift of Fritz Kaeser

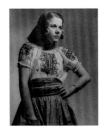

2 *Girl in a Folk Costume*
 (Milly Kaeser), circa 1935
(Portfolio Pictorial)
13 x 10.5 in. (33 x 26.7 cm.)
82.87.12.H
Gift of Fritz Kaeser

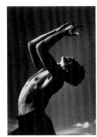

3 *José Limón, Dance of Mexico, 1941*
(Portfolio Pictorial)
13 x 10 in. (33 x 25.4 cm.)
80.29.23
Gift of Fritz Kaeser

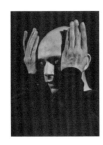

4 *Harald Kreutzberg, circa 1940*
(Portfolio Pictorial)
14 x 11 in. (35.6 x 27.9 cm.)
80.29.24
Gift of Fritz Kaeser

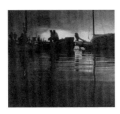

5 *The Dreamers, 1934*
(Portfolio Pictorial)
9 x 10.75 in. (22.9 x 27.3 cm.)
80.29.25
Gift of Fritz Kaeser

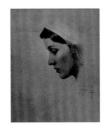

6 *Study of Hands, 1933*
(Portfolio Pictorial)
12 x 10 in. (30.5 x 25.4 cm.)
80.29.26
Gift of Fritz Kaeser

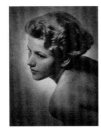

7 *Francesca, Student Actress,*
 Madison, circa 1934
(Portfolio Pictorial)
13 x 10 in. (33 x 25.4 cm.)
80.29.29
Gift of Fritz Kaeser

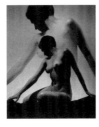

8 *Myrtoclea, 1935*
(Portfolio Pictorial)
11 x 9 in. (27.9 x 22.9 cm.)
80.29.30
Gift of Fritz Kaeser

9 *Figure, 1939*
(Portfolio Pictorial)
13 x 10 in. (33 x 25.4 cm.)
80.29.33
Gift of Fritz Kaeser

10 *Robert Louis Stevenson Portrayed by*
 George Dunham, 1932
(Portfolio Pictorial)
12 x 10 in. (30.5 x 25.4 cm.)
80.29.34
Gift of Fritz Kaeser

11 *My Swiss Uncle Jake, circa 1940*
(Portfolio Pictorial)
10 x 8 in. (25.4 x 20.3 cm.)
80.29.21
Gift of Fritz Kaeser

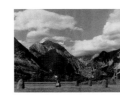

12 *Isonzo Valley, Italy, 1945*
(Portfolio Travel)
11 x 13.75 in. (27.9 x 34.9 cm.)
aa 97.41.17.A
Gift of Milly Kaeser

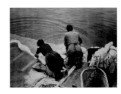

13 *Washing in Lago di Garda, Italy, 1945*
(Portfolio Travel)
8 x 11.6 in. (20.3 x 29.5 cm.)
aa 97.41.17.B
Gift of Milly Kaeser

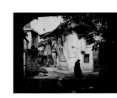

14 *Zirocco, Venezia, Italy, 1945*
(Portfolio Travel)
6.6 x 9.5 in. (16.8 x 24.1 cm.)
aa 97.41.14.F
Gift of Milly Kaeser

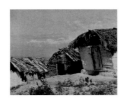

15 *Haitian Huts, 1946*
(Portfolio Travel)
10.4 x 13.4 in. (26.4 x 34 cm.)
aa 97.41.22.A
Gift of Milly Kaeser

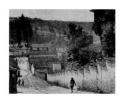

16 *Chichicastenango, Guatemala, 1946*
(Portfolio Travel)
10.8 x 14 in. (27.4 x 35.6 cm.)
aa 97.41.52.Y
Gift of Milly Kaeser

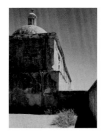

17 *Abandoned Mexican Church, 1946*
(Portfolio Travel)
14 x 11 in. (35.6 x 27.9 cm.)
aa 97.41.88.Q
Gift of Milly Kaeser

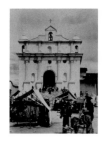

18 *Guatemala: Chichicastenango Market*
& Church, 1946
(Portfolio Travel)
13 x 10 in. (33 x 25.4 cm.)
Temporary accession no. 1
Gift of Fritz Kaeser

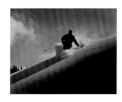

19 *André Roch Skiing, 1949*
(Portfolio Landscape Mountain
Snow and Snow Scenes)
9.25 x 12 in. (23.5 x 30.5 cm.)
79.35.02.H
Gift of Fritz Kaeser

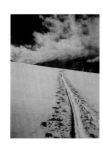

20 *Ski Trail on Richmond Hill*
(Aspen, Colorado), 1941
(Portfolio Landscape Mountain
Snow and Snow Scenes)
14 x 11 in. (35.6 x 27.9 cm.)
79.35.02.B
Gift of Fritz Kaeser

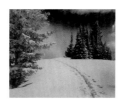

21 *Ski Trail on Aspen Mountain, 1949*
(Portfolio Landscape Mountain
Snow and Snow Scenes)
11 x 14 in. (27.9 x 35.6 cm.)
79.35.02.C
Gift of Fritz Kaeser

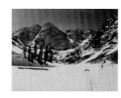

22 *Mike Magnifico at Maroon Bells, 1943*
(Portfolio Landscape Mountain
Snow and Snow Scenes)
11 x 14 in. (27.9 x 35.6 cm.)
79.35.02.J
Gift of Fritz Kaeser

23 *Aspen Slopes, circa 1950*
(Portfolio Landscape Mountain
Snow and Snow Scenes)
11 x 14 in. (27.9 x 35.6 cm.)
aa 97.41.05.N
Gift of Milly Kaeser

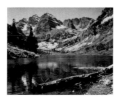

24 *Maroon Bells and Lake,*
Aspen, Colorado, 1952
(Portfolio Landscape)
11 x 14 in. (27.9 x 35.6 cm.)
80.29.09.H
Gift of Fritz Kaeser

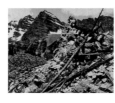

25 *Maroon Peaks and Rocks, 1949*
(Portfolio Landscape)
9 x 12 in. (22.9 x 30.5 cm.)
80.29.09.I
Gift of Fritz Kaeser

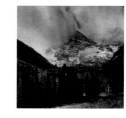

26 *Maroon Bells, Cloudy, 1951*
(Portfolio Landscape)
8 x 10 in. (20.3 x 25.4 cm.)
81.55.12.A
Gift of Fritz Kaeser

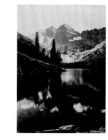

27 *Maroon Bells, 1949*
(Portfolio Landscape)
12.25 x 9.75 in. (31.1 x 24.8 cm.)
81.55.12.J
Gift of Fritz Kaeser

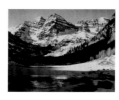

28 *Maroon Bells, Winter, 1949*
(Portfolio Landscape)
9.5 x 12.25 in. (24.9 x 31.1 cm.)
81.55.12.K
Gift of Fritz Kaeser

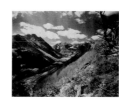

29 *Maroon Bells, 1948*
(Portfolio Landscape)
10.5 x 13.25 in. (26.7 x 33.7 cm.)
81.55.12.M
Gift of Fritz Kaeser

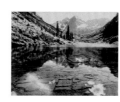

30 *Maroon Lake, 1951*
(Portfolio Landscape)
11 x 13 in. (27.9 x 33 cm.)
aa 97.41.08.H
Gift of Milly Kaeser

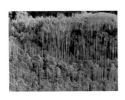

31 *Aspen Trees, Autumn, October 1950*
(Portfolio Aspens)
11 x 14 in. (27.9 x 35.6 cm.)
79.35.04.A
Gift of Fritz Kaeser

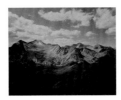

36 *Snowmass Lake, Pitkin County,
Aspen, 1940s*
(Portfolio Landscape)
7.4 x 9.5 in. (18.8 x 24.1 cm.)
aa 97.41.14.A
Gift of Milly Kaeser

41 *Texas Canyon No. 5, 1955*
(Portfolio Desert Landscape)
11 x 10.4 in. (27.9 x 26.4 cm.)
82.87.03.E
Gift of Fritz Kaeser

32 *Aspen Leaves, 1952*
(Portfolio Aspens)
11 x 14 in. (27.9 x 35.6 cm.)
79.35.04.H
Gift of Fritz Kaeser

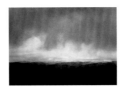

37 *Mountain Storm, 1951*
(Portfolio Landscape)
9 x 12 in. (22.9 x 30.5 cm.)
aa 97.41.16.O
Gift of Milly Kaeser

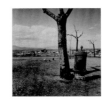

42 *Tombstone, Arizona, 1954*
(Portfolio Desert Landscape)
11 x 10.4 in. (27.9 x 26.4 cm.)
82.87.03.H
Gift of Fritz Kaeser

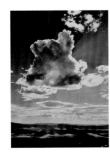

33 *Yampa Valley, Colorado, 1940*
(Portfolio Landscape Mountain)
13.8 x 10.8 in. (35 x 27.4 cm.)
aa 97.41.02.B
Gift of Milly Kaeser

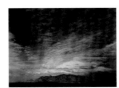

38 *Mount Lemon and Tucson, 1950s*
(Portfolio Desert Landscape)
10.8 x 13.8 in. (27.4 x 35 cm.)
aa 97.41.36.O
Gift of Milly Kaeser

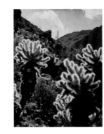

43 *Cholla Landscape, 1951*
(Portfolio Desert Landscape)
9.3 x 7.3 in. (23.6 x 18.5 cm.)
aa 97.41.33.Q
Gift of Milly Kaeser

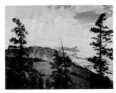

34 *Castle and Cathedral Peaks,
Colorado, 1954*
(Portfolio Landscape)
11 x 14 in. (27.9 x 35.6 cm.)
80.29.09.F
Gift of Fritz Kaeser

39 *Untitled (Desert and Sky), 1950s*
(Portfolio Desert Landscape)
10.8 x 14 in. (27.4 x 35.6 cm.)
aa 97.41.36.S
Gift of Milly Kaeser

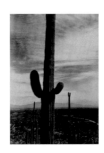

44 *Saguaro, 1953*
(Portfolio Saguaro)
14 x 10.9 in. (35.6 x 27.7 cm.)
79.35.09.D
Gift of Fritz Kaeser

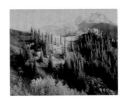

35 *Untitled (Colorado), 1940s*
(Portfolio Landscape)
10.8 x 13.8 in. (27.4 x 35 cm.)
aa 97.41.09.M
Gift of Milly Kaeser

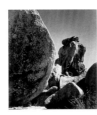

40 *Texas Canyon No. 4, 1955*
(Portfolio Desert Landscape)
9.4 x 8.6 in. (23.9 x 21.8 cm.)
aa 97.41.39.L
Gift of Milly Kaeser

45 *Cholla and Saguaro, 1954*
(Portfolio Desert Landscape)
13 x 9.6 in. (33 x 24.4 cm.)
aa 97.41.23.A
Gift of Milly Kaeser

46 *Untitled (Clouds Over Hills), 1950s*
(Portfolio Desert Landscape)
3.6 x 4.6 in. (9.1 x 11.7 cm.)
aa 97.41.31.L
Gift of Milly Kaeser

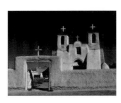

47 *Untitled (Hills and Cacti), 1950s*
(Portfolio Desert Landscape)
3.6 x 4.6 in. (9.1 x 11.7 cm.)
aa 97.41.31.M
Gift of Milly Kaeser

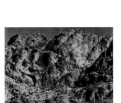

48 *Ranchos De Taos Mission,*
St. Francis of Assisi Parish, 1942
(Portfolio Mission)
9.5 x 12 in. (24.1 x 30.5 cm.)
79.35.12.D
Gift of Fritz Kaeser

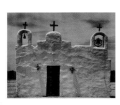

49 *Komelik, Papago Indian Village*
Church, 1963
(Portfolio Mission)
11 x 14 in. (27.9 x 35.6 cm.)
aa 97.41.28.C
Gift of Milly Kaeser

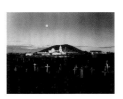

50 *San Xavier Moonrise, 1952*
(Portfolio Mission)
11 x 14 in. (27.9 x 35.6 cm.)
aa 97.41.28.D
Gift of Milly Kaeser

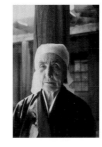

51 *Georgia O'Keeffe No. 4, 1968*
Proof print from portrait sitting,
Ghost Ranch, New Mexico,
May 1968
3.25 x 2.25 in. (8.5 x 6 cm.)
Item 3174, Fritz Kaeser Film Archives
Gift of Milly Kaeser

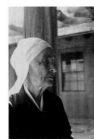

52 *Georgia O'Keeffe No. 8, 1968*
Proof print from portrait sitting,
Ghost Ranch, New Mexico,
May 1968
3.25 x 2.25 in. (8.5 x 6 cm.)
Item 3179, Fritz Kaeser Film Archives
Gift of Milly Kaeser

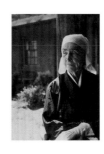

53 *Georgia O'Keeffe No. 10, 1968*
Proof print from portrait sitting,
Ghost Ranch, New Mexico,
May 1968
3.25 x 2.25 in. (8.5 x 6 cm.)
Item 3181, Fritz Kaeser Film Archives
Gift of Milly Kaeser

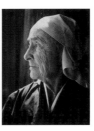

54 *Georgia O'Keeffe No. 12, 1968*
Proof print from portrait sitting,
Ghost Ranch, New Mexico,
May 1968
3.25 x 2.25 in. (8.5 x 6 cm.)
Item 3183, Fritz Kaeser Film Archives
Gift of Milly Kaeser

55 *Georgia O'Keeffe, 1968*
(Portfolio Desert Landscape)
9.7 x 7.7 in. (24.6 x 19.6 cm.)
aa 97.41.39.B
Gift of Milly Kaeser

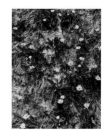

56 *Melting Snow, Praise the Lord, 1954*
(Portfolio Flower)
12 x 9.5 in. (30.5 x 24.1 cm.)
82.87.9.A
Gift of Fritz Kaeser

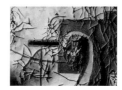

57 *Linoleum Texture from Old Mine Smelter,*
Sasco, 1953
(Portfolio Artifact)
9 x 13 in. (22.9 x 33 cm.)
79.35.13.B
Gift of Fritz Kaeser

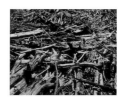

58 *Log Jam, 1953*
(Portfolio Mountain Texture
Form Design)
9.5 x 12.4 in. (24.1 x 31.5 cm.)
79.35.03.F
Gift of Fritz Kaeser

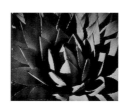

59 *Decaying Saguaro Close-up, 1953*
(Portfolio Desert Texture
Form Design)
14 x 10.9 in. (35.6 x 27.7 cm.)
79.35.09.M
Gift of Fritz Kaeser

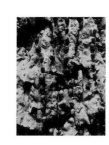

60 *Huachuca Agave, 1954*
(Portfolio Desert Texture
Form Design)
16 x 20 in. (40.6 x 50.8 cm.)
80.29.05.C
Gift of Fritz Kaeser

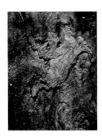

61 *Wood Texture Mountain*
 Series No. 8, 1953
 (Portfolio Wood Texture)
 9.4 x 7.5 in. (24 x 19 cm.)
 aa 97.41.14.J
 Gift of Milly Kaeser

62 *Desert Form and Texture, 1950s*
 (Portfolio Desert Landscape)
 9.5 x 7.4 in. (24.1 x 18.8 cm.)
 aa 97.41.14.L
 Gift of Milly Kaeser

63 *Arizona Rock, 1950s*
 (Portfolio Desert Texture)
 9.5 x 7.5 in. (24.1 x 19 cm.)
 aa 97.41.14.O
 Gift of Milly Kaeser

64 *Untitled (Cactus Spines), 1950s*
 (Portfolio Desert Texture)
 4.7 x 3.8 in. (11.9 x 9.6 cm.)
 aa 97.41.31.A
 Gift of Milly Kaeser

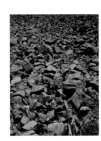

65 *Talus, 1952*
 (Portfolio Mountain Texture
 Form Design)
 4.7 x 3.7 in. (11.9 x 9.4 cm.)
 aa 97.41.31.E
 Gift of Milly Kaeser

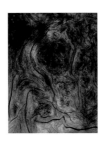

66 *Wood in Rain, 1953*
 (Portfolio Mountain Texture
 Form Design)
 4.6 x 3.6 in. (11.7 x 9.1 cm.)
 aa 97.41.31.F
 Gift of Milly Kaeser

67 *Lichen Face, 1950s*
 (Portfolio Mountain Texture)
 7.3 x 9.7 in. (18.5 x 24.6 cm.)
 aa 97.41.33.I
 Gift of Milly Kaeser

68 *Diagram by a Mountain Termite*
 No. 1, 1961
 (Portfolio Wood)
 18 x 14 in. (45.7 x 35.6 cm.)
 79.35.07.B
 Gift of Fritz Kaeser

69 *Wood Texture B, 1969*
 (Portfolio Wood)
 10.9 x 14 in. (27.7 x 35.6 cm.)
 79.35.07.O
 Gift of Fritz Kaeser

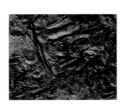

70 *Untitled (Slag, Sasco), 1960s*
 (Portfolio Rock Texture)
 13.5 x 17.3 in. (34.3 x 43.9 cm.)
 aa 97.41.39.T
 Gift of Milly Kaeser

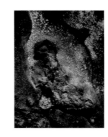

71 *Untitled, 1960s*
 (Portfolio Rock Texture)
 16 x 12.5 in. (40.6 x 31.8 cm.)
 aa 97.41.61.K
 Gift of Milly Kaeser

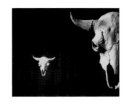

72 *Evolution, 1977*
 (Portfolio Apparition)
 10.9 x 13.4 in. (27.7 x 34 cm.)
 aa 97.41.39.N
 Gift of Milly Kaeser

73 *Artifacts: Buffalo, 1981*
 (Portfolio Artifacts)
 8 x 10 in. (20.3 x 25.4 cm.)
 81.55.01.B
 Gift of Fritz Kaeser

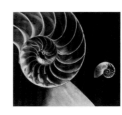

74 *Sea Shells, Chambered Nautilus, 1983*
 (Portfolio Artifacts of Nature)
 10.8 x 13.9 in. (27.4 x 35.3 cm.)
 84.46.02
 Gift of Fritz Kaeser

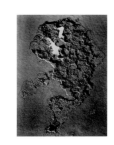

75 *Termite, 1980*
 (Portfolio Apparition)
 12.25 x 9.6 in. (31.1 x 24.4 cm.)
 81.55.14.G
 Gift of Fritz Kaeser

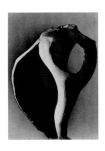

76 *Sea Shells, Eroded Sea Shell No. 10, 1983*
(Portfolio Artifacts of Nature)
13.9 x 10.8 in. (35.3 x 27.4 cm.)
84.46.08
Gift of Fritz Kaeser

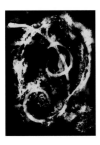

77 *Untitled (Painting on Film), 1970s*
(Portfolio Apparition)
14 x 11 in. (35.6 x 27.9 cm.)
aa 97.41.76.E
Gift of Milly Kaeser

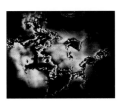

78 *Multi Solarization No. 10, 1979*
(Portfolio Clouds)
10 x 12 in. (25.4 x 30.5 cm.)
81.55.10.A
Gift of Fritz Kaeser

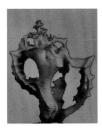

79 *Sea Shells, Eroded Sea Shell No. 12, 1983*
(Portfolio Artifacts of Nature)
12.1 x 9.5 in. (30.7 x 27.4 cm.)
84.46.09
Gift of Fritz Kaeser

80 *Untitled, circa 1977*
(Portfolio Zen Painted)
20 x 16 in. (50.8 x 40.6 cm.)
aa 97.41.71.I
Gift of Milly Kaeser

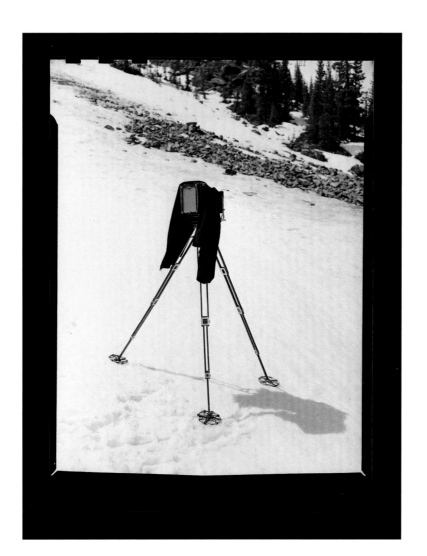

The images in *Fritz Kaeser: A Life in Photography* were prepared and the book printed by Mossberg & Company Inc., South Bend, Indiana, on 115-pound Utopia Premium Gloss Text in an edition of 1,500 copies with binding by Zonne Bookbinders, Inc., Chicago, Illinois.

The book and jacket were designed by Will H. Powers, and composed at Stanton Publication Services, Inc., St. Paul, Minnesota.

Text was set in ITC Legacy Sans, a companion typeface to Legacy Serif. These fonts reinterpret Renaissance typographic masterpieces as digital letterforms. With Legacy Serif, designer Ron Arnholm took that reinterpretation another step. He created sans serif letters based upon an italic cut by Claude Garamond *circa* 1539 in Paris and upon a roman face cut by Nicolas Jenson in Venice *circa* 1469. The display type is Penumbra, designed by Lance Hidy in 1994.